Revolutionary Women

Revolutionary Women

50 WOMEN of COLOR WHO REINVENTED the RULES

Ann Shen

CHRONICLE BOOKS

SAN FRANCISCO

Library of Congress Cataloging-in-Publication Data

Names: Shen, Ann, author.

Title: Revolutionary women / Ann Shen.

Description: San Francisco : Chronicle Books, [2022] | Includes bibliographical references.

Identifiers: LCCN 2022007098 (print) | LCCN 2022007099 (ebook) | ISBN 9781452184593 (hardcover) | ISBN 9781797221236 (ebook)

Subjects: LCSH: Minority women--History. | Minority women--Biography. | Women social reformers--Biography.

Classification: LCC HQ1161 .S44 2022 (print) | LCC HQ1161 (ebook) | DDC 305.42--dc23/eng/20220330

LC record available at https://lccn.loc.gov/2022007098

LC ebook record available at https://lccn.loc.gov/2022007099

Manufactured in Italy.

Design by Rachel Harrell.

10 9 8 7 6 5 4 3 2 1

Chronicle books and gifts are available at special quantity discounts to corporations, professional associations, literacy programs, and other organizations. For details and discount information, please contact our premiums department at corporatesales@chroniclebooks.com or at 1-800-759-0190.

Chronicle Books LLC

680 Second Street

San Francisco, California 94107

www.chroniclebooks.com

For my parents, Yu and Tien, who always
made me feel like I was somebody.

For everyone who's never felt seen.

And for Ryan, always.

Contents

Introduction

In a time when history books on women have become their own genre, I wanted to write a book that features something close to my heart—a book with historically underrepresented women as the leads. The lives and work of BIPOC women—Black, Indigenous, East Asian, South Asian, Latinx, LGBTQIA+, and other underrepresented women—have long been passed over, largely due to who gets to tell their story and a historically white publishing industry. I'm writing this book to create space for underrepresented women who have impacted the world in marvelous ways but may have had their stories left behind. More than that, this book is about the vibrant, multifaceted lives these women led and are still leading. What follows in these pages are stories of people who had big dreams, great loves, and joyful triumphs along with rejections and missteps like everyone else. This is a book that represents the multiracial and multiethnic world of people who shaped (and continue to shape) our modern society.

When we talk about BIPOC and LGBTQIA+ people who are historically underrepresented, we often focus on how difficult their experiences have been and how sad their lives are in a postcolonial society. But our lives are so much bigger than that. I want to share the stories of these real people who had very real, full lives. As a second-generation child of Taiwanese immigrants and woman of color, I want to be remembered for the dreams I achieved, people I loved, and impact I made—not the systemic challenges that were always going to be rigged against me. We are not defined by that. And as the women in the following pages will prove, many of our dreams come true. And when they do, it's not just for us; it's for everyone who helped us, believed in us, and came after us.

I rarely think about the color of my skin, especially in terms of limiting my dreams, even if other people do the moment they see me. I think about what I want to do with this one and only adventure I get to be on in this lifetime,

and I think about the people I can help with my work and my life. These dreams are shaped by my personal life experiences and cultural heritage—something every individual is impacted by in their own lives. Race and ethnicity are not, and should not be, impediments to living out our dreams, but cannot be ignored as factors that make us who we are too. Every one of the women chronicled in these pages had big dreams and worked hard to make them come true. By creating art, organizing communities, inventing in STEM, expressing their spirits, and pursuing greater goals, these women started small revolutions that would snowball into greater advancement for all people—especially underrepresented women. Some had ambitions so great they weren't accomplished in one lifetime alone, but their impact would be felt for generations to come. There would be no Mae Jemison without Bessie Coleman.

It is the richness of our diverse backgrounds that makes life so beautiful and interesting. When we come together to achieve things and inspire one another, it brings out the best we can be as humans. When we forge a new path, we leave space for people to come after us and grow beyond the things we created. There's so much wisdom to be shared through our many different experiences. We only live our one life, but when we read, we get to live the experience of others. I'm hoping that these women's stories become a part of your life too.

So this book exists to help you find people who made paths where there were none. To see what people pursued with great passion and to discover who cracked glass ceilings will maybe help you find a path of your own. My hope through sharing their stories is that you will also start your own revolutions.

All my love,

Ann Shen

PS: While I regret that this book could never contain the billions of underrepresented women who have lived and who racially make up the global majority, I'm proud to share the stories of many women people should get to know. This is by no means a definitive list. I also didn't include any women from my previous books, to give space to people I haven't shared before.

IN PURSUIT OF

Art

Dorothy Toy

May 28, 1917–July 10, 2019

CELEBRATED DANCER WHO WOWED THE WORLD

Dorothy Toy was a Japanese American dancer who tapped her way across the globe and back with her partner, Paul Wing, in the 1930s to 1960s. They were the first Asian American dancers in show business, and they appeared in films and stages around the world—including the 1948 gangster feature *No Orchids for Miss Blandish.* Talented, glamorous, and hardworking, Toy was a pioneer for Asian Americans in dance, film, and theater, fields that still don't provide a lot of opportunities for Asian Americans.

> "When you take your bows at the end, it hits me . . . money doesn't count. You get that pleasure inside your heart."

1917

Born in San Francisco, Toy was raised in Los Angeles, where her parents owned a restaurant across the street from a vaudeville theater, The Regent. The theater manager spotted a young Toy dancing en pointe in front of her parents' restaurant and encouraged them to put her in dance classes. Without much money, her parents traded food for lessons for their young daughter and supported her pursuit of dance. Her first teacher was Russian, and the Cossack moves she learned from him helped shape her style.

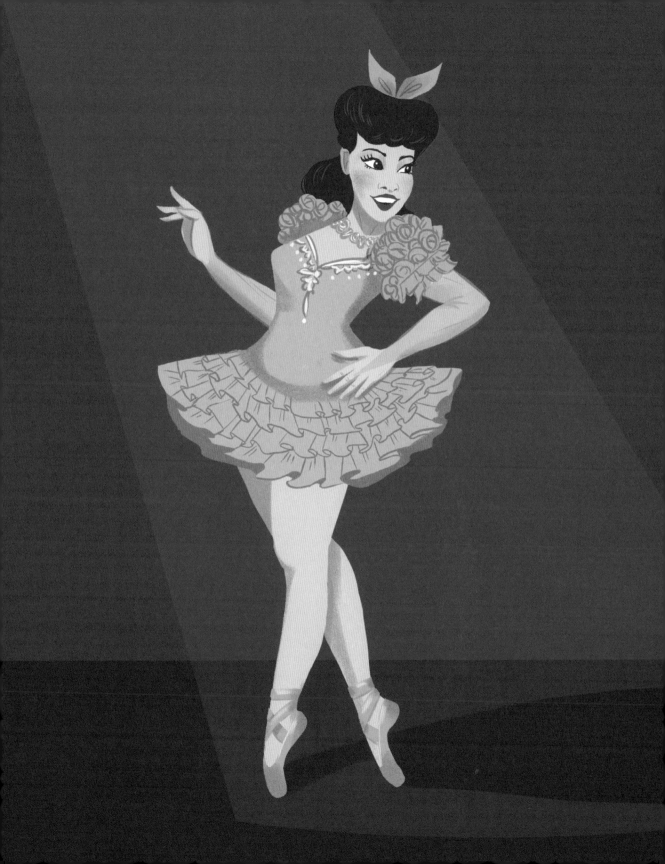

1934

Toy and her sister, Helen, appeared in the film *Happiness Ahead*. While auditioning for roles, they frequently ran into Paul Wing, and the young Chinese American dancer suggested they form a trio. The Three Mahjongs were born.

1936

Toy graduated from high school and the Three Mahjongs head to Chicago for bright lights and stages. Helen soon left the act to pursue singing, and Toy and Wing started performing together. The duo became known for their unique mix of soft-shoe, jitterbugging, Lindy, and ballet-influenced ballroom dancing.

1940–1945
The War Years

Toy and Wing married for convenience because it was easier to travel as a married couple. After Japan attacked Pearl Harbor in 1941, anti–Japanese sentiment became rampant in the United States. A rival dance group leaked that Toy was of Japanese descent, and Toy and Wing lost a film contract with Chico Marx, one of the Marx Brothers. Then Wing was drafted into the US military, and after he returned from his tank unit in Normandy, he suffered from shell shock (now better known as PTSD). They ended their marriage and moved back to San Francisco for a steady gig performing at the Forbidden City nightclub. Toy loved performing for an Asian and Asian American audience and being a part of the community again.

1960

Toy formed her own dance troupe, the Oriental Playgirl Revue. Low on funds, she put together a clever marketing campaign featuring the dancers wearing only open umbrellas that caught the eye of many theater promoters. The troupe, Toy, and Wing performed together worldwide in Europe, South America, and Japan.

cont.

1937

Toy and Wing caught the attention of talent agents and soon signed with the William Morris Agency. They appeared in the musical short *Deviled Ham,* after which they were nicknamed the "Chinese Fred Astaire and Ginger Rogers." The moniker helped them gain professional momentum at the time, but undermined their own unique talents and individuality by offering a white counterpart for people to understand their place.

1939

The duo became the first Asian Americans to perform at the London Palladium—just as World War II began. They had to carry gas masks to their performances and perform through blackouts at the Palladium due to bombings.

cont.

They even appeared with Patti LaBelle and Jimmy Borges. The Revue found success for more than a decade, and it featured a unique cocktail of Chinese folk dance and modern jazz. This savvy mix is what made Dorothy Toy such a trailblazer for the Asian American community—her dance innovations helped redefine what being Asian American meant.

MID-1970S
and On

Vaudeville faded in popularity and the Revue came to an end. Finding herself at a new crossroads, Toy told her daughter: "Never say can't, just always say 'I can do everything' and just learn it on the job." She became a pharmacy technician, sold perfume in department stores, and gave dance lessons in her basement studio. Toy continued to teach dance to many kids well into her seventies and celebrated her one hundredth birthday with her beloved community. One of the original members of the Oriental Playgirl Revue, Cynthia Yee, founded the Grant Avenue Follies to preserve Toy's legacy.

Eartha Kitt

January 17, 1927–December 25, 2008

"THE MOST EXCITING WOMAN IN THE WORLD"

The incomparable Eartha Kitt, a Black and Cherokee mixed-race woman, was a charismatic performer who worked in film, television, nightclubs, theaters, and Broadway. Kitt saved herself—from a dirt-poor childhood where she was passed between relatives who didn't want her or abused her—with her talent and charisma. Kitt said: "When I was a child, no one wanted me . . . it's something for me to realize that I am a privileged child, because look at what the public gave me . . . the privilege of being somebody." She had a dazzling six-decade-long career; stayed close with her only daughter, Kitt McDonald; and was an outspoken advocate for civil rights, especially LGBTQIA+ equal rights, her entire life.

> "I think it's a lot of fun being Eartha Kitt, I love every moment of it."

GET TO KNOW EARTHA KITT

1. At sixteen, she joined Katherine Dunham's dance troupe and toured the world before going solo. During her lifetime, she learned to speak four languages and could sing in eleven.

2. She got her solo start as a nightclub singer at the queer nightclub Le Carroll's in Paris.

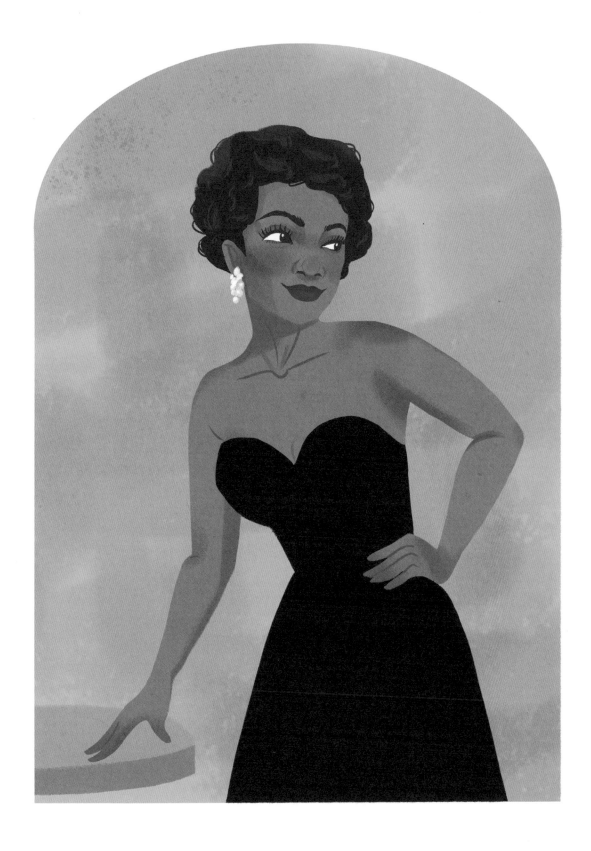

3. Orson Welles cast her in her first starring role, as Helen of Troy; he called her "the most exciting woman in the world."

4. Her Broadway career launched her musical career: Her first album was released in 1954. She produced multiple hit songs throughout her life; her most popular are "I Want to Be Evil," "C'est Si Bon," and "Santa Baby"—an annual favorite—all due to her distinct, purring voice.

5. In 1967, Kitt made her landmark debut as the iconic Catwoman on the TV series *Batman*. She bucked interracial relationship taboos when she flirted shamelessly with Adam West's Batman on-screen.

6. Revlon's iconic lipstick Fire and Ice was created for her by one of her former lovers, Charles Revson, the founder of Revlon.

7. After a White House luncheon in 1968, where she was outspoken in her opposition of the Vietnam War, the CIA kept a fat file on her that derailed her career for the next decade—it labeled her a "sadistic nymphomaniac" and "rude, crude, shrewd and difficult."

8. During her last decade, she made a name for herself as a voice actor; she is especially notable as Yzma in Disney's *The Emperor's New Groove.*

9. After a sparkling career studded with awards and accolades, Kitt often said she preferred the dirt to all the diamonds and gold. She would sell diamonds she received so she could buy more land instead. Near the end of her life, she lived in Beverly Hills with her daughter, where she gardened, grew her own vegetables, and even had backyard chickens (which was unusual in the '60s).

Gloria Estefan

September 1, 1957–

QUEEN OF LATIN POP

With more than one hundred million albums sold and over three dozen number-one singles, Gloria Estefan is one of the bestselling female artists of all time and the highest-selling female Latin American musician at the time of this writing. Estefan was two years old when she and her family emigrated from Cuba to Miami during that country's revolution. As a baby, she could only be calmed by her mother's singing. Music became a lifelong comfort for her and helped her cope with difficult challenges—like her father's declining health. She'd turn that escape into a passion that would lead to her breakthrough in 1980—and her passion paved the way for Latin music to make it into the American mainstream as a formidable category within the industry.

GET TO KNOW GLORIA ESTEFAN

1. In 1975, Estefan joined her first band, the Miami Sound Machine— shortly after she met her husband, Emilio Estefan. Emilio was performing with his band, then the Miami Latin Boys, in short shorts and with an accordion—attracting Gloria's attention. Their partnership formed the Miami Sound Machine, and a marriage in 1978.

2. Estefan and the Miami Sound Machine released their first charting US album, *Primitive Love*, in 1985. They released three more before the band dropped its original name to perform solely under Gloria

Estefan's since she was clearly the star attraction. This era was when they released now iconic Estefan hits "Congo," "Bad Boy," "Anything for You," and "Rhythm Is Gonna Get You."

3. In 1991, while on tour for her first solo album, *Cuts Both Ways*, Estefan was in a terrible tour bus accident that left her paralyzed. Ten months after surgery, painful physical rehab, and regaining the ability to walk, she reemerged at the American Music Awards to perform her new song, "Coming Out of the Dark," cowritten with her husband about their accident.

4. In 1993, she released her first Spanish-language solo album, *Mi Tierra,* to reconnect with her Cuban roots. It became the first number-one album on the new Billboard Top Latin Albums chart and went platinum sixteen times.

5. Estefan is not just a singer. She's acted in films and television series, authored two children's books, and collaborated on a cookbook with her husband.

6. Estefan has won three Grammy awards, was presented with the Presidential Medal of Freedom, has a star on the Hollywood Walk of Fame, and earned the American Music Award for Lifetime Achievement, among many other accolades. She also created a Broadway show of her life and music. She continues to write music for other acts like Shakira and Jennifer Lopez.

7. A lifelong humanitarian, Estefan founded the Gloria Estefan Foundation in 1997 and has supported Florida hurricane relief, AIDS research, and spinal cord research, among many other causes.

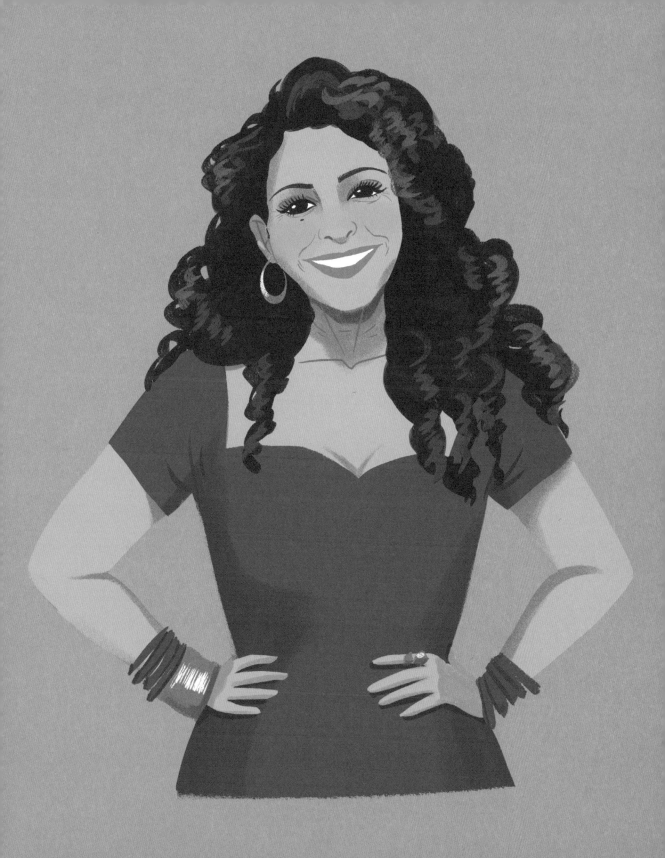

Misty Copeland

September 10, 1982–

FIRST BLACK PRINCIPAL FEMALE DANCER AT THE AMERICAN BALLET THEATRE

In June 2015, Misty Copeland made history when she became the first Black woman promoted to the highest rank of principal dancer at the American Ballet Theatre company. Even though she got a late start in ballet (she didn't take her first class until she was thirteen) and came from very humble roots in Southern California, Copeland shattered the glass ceiling on what was possible for her in just a few short years. Two years into ballet training, she won first place at the Los Angeles Music Center Spotlight Awards. Her exceptional work ethic helped her ascend quickly in the fiercely competitive ballet world, collecting accolades and title roles in prestigious, historic ballets like *The Firebird*, *The Nutcracker*, and *Swan Lake* in equal measure.

However, it is her heartfelt work in promoting equality and diversity in one of the most ivory of white towers—the ballet world—that is so impactful to so many young dancers and artists to come. Even after a challenging childhood, suffering major injuries, and overcoming body issues, Copeland continued to triumph and grow through the help of mentors—including Prince, who collaborated with her for the music video of his song "Crimson and Clover." She found that her own confidence and joy in dancing were more important to her artistic expression than fitting the ideal ballerina mold—and in doing so, broke the mold. Copeland is a champion of diversity in the field—her work not only shares the beauty of ballet but also demonstrates that a Black ballerina

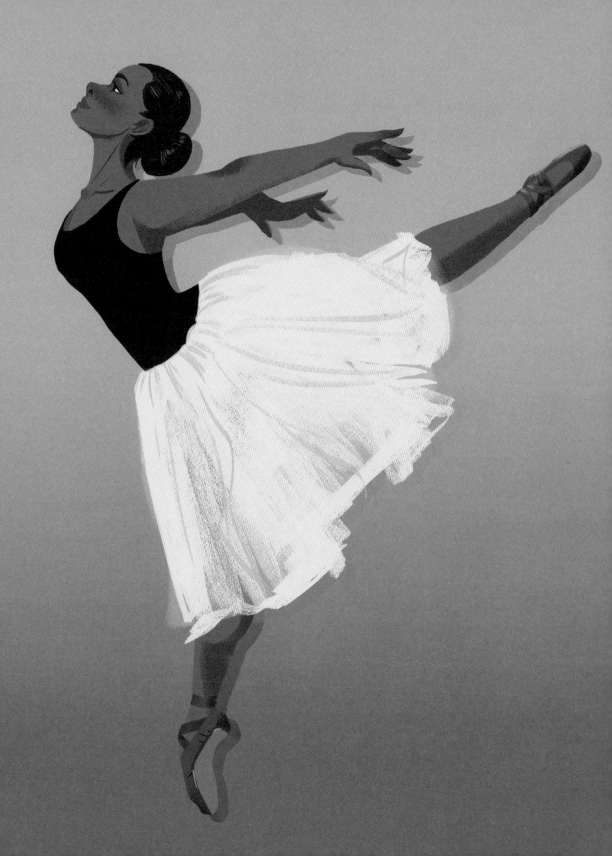

who's shorter and more muscular than traditionally accepted can be at the top of the game. She's outspoken about the inequalities that continue to demand more labor from or even shut out dancers with darker skin tones. For example, up until recently, non-white dancers still had to "pancake" their ballet shoes—meaning to powder the "European pink" shoes with a foundation that matches their skin tones so their shoes can match their bodies. Because of Misty's influence and prominence in the ballet world, companies started to manufacture different shades of tights and shoes for a broad range of skin tones—a huge win for inclusion.

Copeland started dancing because she loved it, and by courageously pursuing something she loved, she created space for future generations of dancers with diverse bodies and made the world a more inclusive place.

"You can start late, look different, be uncertain, and STILL Succeed."

— MISTY COPELAND

Nancy Kwan

May 19, 1939–

INTERNATIONAL FILM STAR

A trailblazer in Hollywood for Asian Americans, Chinese British star Nancy Kwan possesses a je ne sais quois and gamine grace that made her an irresistible breakout star the moment she stepped on screen. With her sparkling talent, ability to speak Cantonese, and savvy understanding of both Asian and European audiences, Kwan was able to both break through in Hollywood and find international success. She's appeared in more than fifty films and also dabbled in television, but she's most well known for starring in the 1960 romantic drama *The World of Suzie Wong* and the 1961 cinematic adaptation of Rodgers and Hammerstein's *Flower Drum Song*. The latter would be the first major studio film starring an all-Asian cast, an achievement that wouldn't happen again until thirty-two years later with *The Joy Luck Club*.

> "I believe in that. Going out on a limb to test yourself. It's what makes life interesting."

GET TO KNOW NANCY KWAN

1. During Japan's invasion of Hong Kong in 1941, Kwan and her brother were smuggled out on foot in a wicker basket.

2. Kwan won a Golden Globe for her performance in *The World of Suzie Wong*.

3. She's a professionally trained dancer—she was accepted to London's Royal Ballet and trained as a dancer for four years.

4. Her performance of "I Enjoy Being a Girl" in *Flower Drum Song* became iconic.

5. Her appearance in *The World of Suzie Wong* was in some ways a happy accident. On a trip home to Hong Kong, Kwan went to the studio where they were auditioning for *The World of Suzie Wong* to admire her favorite actors. Her dad had built the studio, so she had special access, and she happened to meet *Suzie Wong* producer Ray Stark, who asked her to audition. She claims she "giggled all the way through" the screen test but was promising enough that the studio sent her to six months of acting lessons and to understudy the lead actress with the touring production. With much guidance from Stark and her costar William Holden, she landed the lead role that would change her life.

6. When her October 1960 cover of *Life* magazine came out, her yellow cheongsam sparked a nationwide fashion trend. The cheongsam was also a symbol of liberation and personal expression for Chinese women during this era.

7. Kwan was one of the first models of the Vidal Sassoon iconic bob; the haircut became known as "The Kwan" and appeared in American and British Vogue.

8. While much of her work is in front of the camera, Kwan has also written and produced several films about and starring Asian Americans.

Tracey Norman

1952–

WORLD'S FIRST BLACK TRANS MODEL

One fateful day in New York City, twenty-five-year-old Tracey Norman spotted a group of Black models standing outside the Pierre Hotel before a fashion show. She quietly followed them up the elevator into what turned out to be a casting call in front of an Italian *Vogue* editor, a Basile fashion designer, and famed photographer Irving Penn. She caught Penn's eye and was booked for a two-day shoot. A model was born. Under Penn's wing, Norman was signed by the Zoli agency and went on to be photographed for multiple *Essence* magazine spreads, get a contract with Avon's skin care line, and become the face of Clairol's Born Beautiful No. 512 Dark Auburn hair dye box. It would become one of the bestselling colors in the line; women clambered to get Norman's naturally beautiful deep auburn hair color. Five years into her amazing career, things came crashing down when Norman was outed as a trans woman by a hairdresser on set for what could have been her first *Essence* cover shoot. In the 1980s, things were changing, but not fast enough.

Norman then escaped to Paris with a friend, where no one had heard the rumors yet. She got a job as a studio model for Balenciaga, which helped rebuild her confidence enough to eventually come back to the States. Once home, she landed a beauty contract immediately, but the whispers persisted, and her modeling career never recovered. After several difficult years, which she survived with the support of her loving mother, she found work in burlesque peep shows starring trans women. There, she was introduced to the drag-ball community, first attending and

"I've always said that the Person that walks through the DOOR First leaves the door CRACKED."

—TRACEY NORMAN

then joining in. She eventually became the mother—or head—of the House of Africa, one of the teams that competes at the balls. Norman was especially celebrated for her performances where she'd use her modeling talents to strut out in jeans and a T-shirt, pull out a handkerchief in front of the judges, and wipe her face to show that she was wearing no makeup. The room would go wild. The community still goes wild for her now—celebrated performers Janet Mock and Laverne Cox both credit Norman with cracking that glass ceiling for them.

Yayoi Kusama

March 22, 1929–

REVOLUTIONARY FINE ARTIST

EARLY YEARS

Yayoi Kusama was born into a wealthy family of seed and plant merchants in Matsumoto, Japan. Hers was a deeply unhappy childhood, with a controlling, abusive mother and an absent, philandering father. Her mother would send her to spy on her father with his mistresses, which led to trauma that she would deal with in her work later in life. Kusama learned to draw by sitting in her family's gardens, but at ten years old she started hallucinating that the flowers and pumpkins were talking to her and would draw compulsively as a means of self-soothing after these episodes. At thirteen, she worked in an enclosed, dark military factory sewing parachutes during World War II while air raid alerts rang daily. By night, she prolifically painted more than seventy watercolors a day of intricate flowers.

BECOMING AN ARTIST

At nineteen, Kusama had a brief stint studying Nihonga painting (a style of antique Japanese painting that involved applying pigment with glue) at the Kyoto Municipal School of Arts and Crafts. Her first solo exhibition was held at the First Community Centre and featured 250 pieces in watercolor, gouache, and oil paint. She held four more solo shows before she discovered the work of Georgia O'Keeffe in a bookstore. Boldly, she wrote to the American artist, who responded.

MAKING IT IN MANHATTAN

The correspondence with O'Keeffe was enough to encourage Kusama to move to the United States in

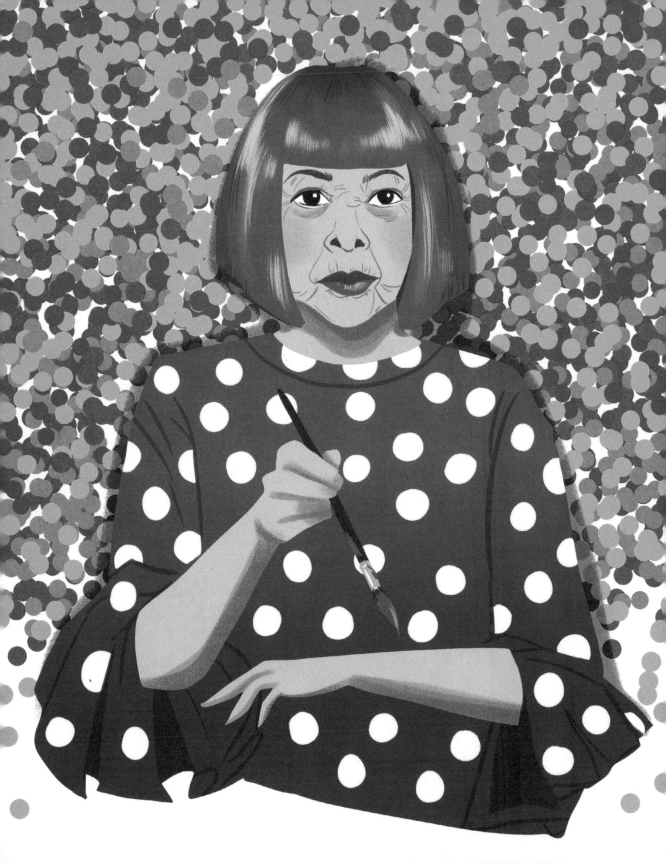

1957, with money sewn into her garments and two thousand of her original pieces. She burned the remaining pieces that were at her parents' house before she left. After a solo show in Seattle, she made her way to Manhattan, where she lived in squalor at first—a door served as her bed, and she would paint all night just to stay warm. There, she began her Infinity Net paintings. Fearlessly confident, Kusama would carry canvases to show museum after museum, despite rejections, and crashed art scene parties where she quickly made friends with artists like Andy Warhol, Donald Judd, and Eva Hesse.

A TASTE OF SWEET SUCCESS AND BITTER BETRAYAL

Through friends, she quickly made connections that led to her first New York solo show of paintings in 1959. Her iconic installation of hand-sewn phallic soft sculpture pieces made their debut in 1963's solo show at the Gertrude Stein Gallery. She debuted her first mirror room in 1965 in a small gallery but failed to sell. (She's since produced more than twenty mirror rooms that are highly sought permanent installations in major museums like the Tate Modern in London and The Broad in Los Angeles.) Though her work was gaining attention and positive reviews, she wasn't making any profit. Then her male contemporaries started to take too much inspiration from her work, and they gained a lot more traction and money for it. Following these troubled times, she made her first suicide attempt.

HAPPENINGS AND MORE

In the late '60s and early '70s, Kusama started staging "Happenings"—art protests in public spaces like Central Park and the Brooklyn Bridge that often included nudity and a form of political protest expressing anti-war, free love, and antiestablishment ideas. Many were performance art pieces that were unannounced; a cast of performers would appear naked in a space and

interact with one another while she painted polka dots on them. Her work focused on sexuality and male organs because she said she was horrified by them from her early trauma—so she used her art as therapy. This was one of her most prolific eras; in addition to performance art, she made films and founded a fashion line.

NARCISSUS GARDEN

In 1966, Kusama participated in the Venice Biennale by creating *Narcissus Garden*—an installation composed of hundreds of mirrored silver spheres that floated on the lawn outside the pavilion. Dressed in a gold kimono, Kusama sold each sphere for 1,200 lire (two US dollars) to passersby until the Biennale organizers put a stop to it. The organizers objected to an artist selling her work "like hot dogs or ice cream cones." The piece and performance was a commentary on art publicity and a critique of the commodification of the art market.

RETURN TO JAPAN

After a second suicide attempt and the passing of her longtime partner, Joseph Cornell, Kusama returned to Japan because of her ill health. She started writing prolifically during this time: surrealist poems, plays, and novels. By 1977, she checked herself into a mental hospital that focused on art therapy and decided to become a permanent resident. As her health took a turn for the worse, her fate seemed sealed, until a 1989 New York retrospective of her work changed everything.

REVIVAL

The 1989 retrospective at the Center of International Contemporary Arts organized by Alexandra Munroe in New York sparked renewed interest in Kusama's work. She was officially invited to the Venice Biennale in 1993, where she created another mirrored room installation, this time dotted with polka dot pumpkin sculptures. Her work was suddenly in demand. She created installations of

"self-obliteration"—her name for the themes of her work, which she said portrayed giving up identity to become one with the universe—for multiple exhibits that toured around the world. Kusama's "Infinity Rooms" and pumpkin sculptures have become the most popular exhibits in the world, and her paintings are highly sought after in the art market—one of her Infinity Net paintings sold for $7.9 million in 2019. Now into her ninth decade, she continues creating daily to manage her mental illness through art, a legacy that not only saved her life but made her one of the most successful female contemporary artists to date.

"I wanted to start a revolution, using art to build the sort of society I myself envisioned."

IN PURSUIT OF

Alexandria Ocasio-Cortez

October 13, 1989–

FROM POLITICAL INGENUE TO JUGGERNAUT

In 2018, Alexandria Ocasio-Cortez burst onto the political scene, winning her first election in an incredible upset that unseated a ten-term white male incumbent in New York's Fourteenth Congressional District. She earned each vote by pounding the pavement and knocking on every door—and has the hole-filled shoes to show for it (which are now in a museum collection). And in January 2019, the Bronx-born twenty-nine-year-old became the youngest woman ever sworn in to the United States Congress. No one in the gilded halls of Congress saw her coming.

Her career in politics was sparked in 2008 when the recession hit, and the government left average Americans like Ocasio-Cortez and her family to suffer the consequences of Wall Street decisions. The then–Boston University sophomore experienced her own personal struggle as her father passed away that same year, plunging their family into a precarious financial situation that found her battling probate court to settle his estate and her mother picking up a second job driving buses to keep their family home from foreclosure. After graduation, she moved back to the Bronx and worked two jobs to help her mom keep their home. Between spending her days working at nonprofits and her evenings bartending, Ocasio-Cortez campaigned for progressive Democrat Bernie Sanders and traveled to protest the Dakota Access oil pipeline. That's when she got the

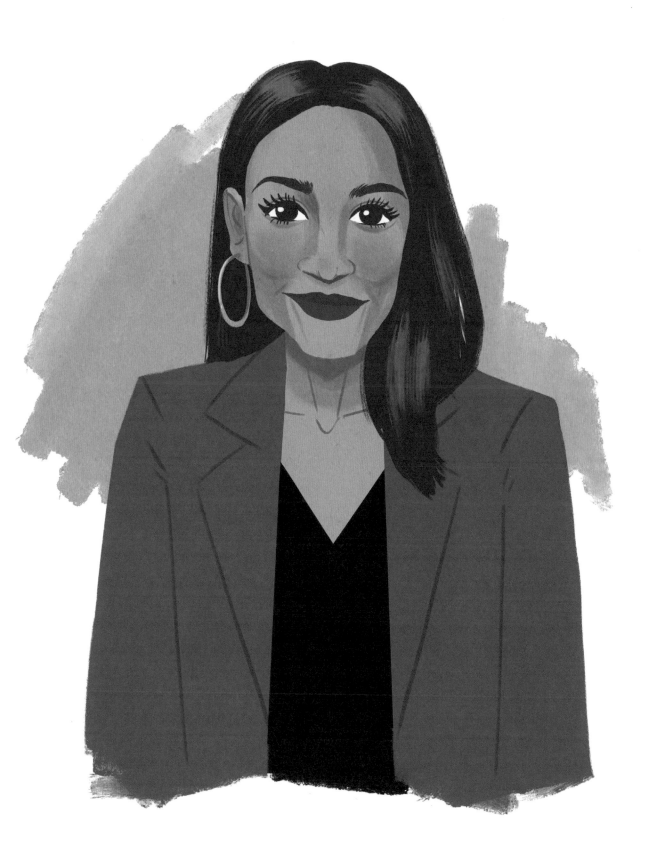

call from Brand New Congress, a political action committee, asking her to run. Her brother had nominated her. With no corporate money, Ocasio-Cortez's grassroots campaign was founded on beliefs of economic justice, of healthcare for all, and that the representative for the Fourteenth district should reflect its mostly working-class Latinx community.

The congresswoman-to-be ran her campaign out of a paper grocery bag that she carried daily from campaigning to bartending. She started by speaking at events that hosted fewer than a dozen people in the living rooms of volunteers, many of whom were former actors-turned-community organizers. Her campaign quickly captured the heart of the millennial generation. She wasn't another rich, privileged, well-connected white man primed for government-business-as-usual service. She was a working-class leader who came of age in the recession and a millennial burdened by exorbitant student loans; someone who felt

the very real concerns plaguing an entire generation. Young volunteers flooded the streets to help her campaign for the weeks leading up to her win.

Now one of the most powerful and notorious figures in DC, she has the political capital leaders twice her age only dream of, and she uses it to fight for a government that works for all of its constituents. Not only that, she's empowered a generation of younger Americans to also pursue political power and get civilly engaged. Ocasio-Cortez is the face of all the young Latinx and BIPOC women who've long been the underdogs holding up American society. And maybe they should have seen her coming—she has an asteroid named after her from winning a high school science fair, after all.

I am experienced enough to do this. I am knowledgeable enough to do this. I am prepared enough to do this. I am mature enough to do this. I am brave enough to do this.

—Alexandria Ocasio-Cortez

Grace Lee Boggs

June 27, 1915–October 5, 2015

ASIAN AMERICAN ACTIVIST AND SOCIAL JUSTICE LEADER

Born in Rhode Island to Chinese immigrant parents, Grace Lee Boggs was a powerful leader of multiracial and multiethnic working-class movements. She studied at Barnard College and Bryn Mawr, earning a PhD in 1940, but couldn't find a job because, as she shared, "even department stores said they weren't hiring Orientals." She got a ten-dollar-a-week job at a library in Chicago, so low paying that she had to live in free housing that was infested with rats. That's when she first got involved in community organizing—she joined the movement for tenant rights. Boggs would go on to participate in the Workers Party and the 1941 March on Washington; she also worked closely with Malcolm X and Martin Luther King Jr. She authored three books—*Revolution and Evolution in the Twentieth Century*; *The Next American Revolution: Sustainable*

Activism for the Twenty-First Century; and an autobiography, *Living for Change*.

Bright, witty, and optimistic, Boggs was inspired by the March on Washington movement's powerful ability to peacefully instigate governmental change to end discrimination. In her thirties, she moved to Detroit to edit the radical newsletter *Correspondence*, where she met her future husband James "Jimmy" Boggs, an auto worker and political activist. Boggs had never planned to get married, but she was attracted to Jimmy's handsomeness as much as she was to his brilliant writing skills. After giving him rides home for a while, she invited him to dinner. He arrived late, turned his nose up at her lamb chop dinner, then "one thing led to another," and he proposed marriage. She said yes and they were "partners in struggle

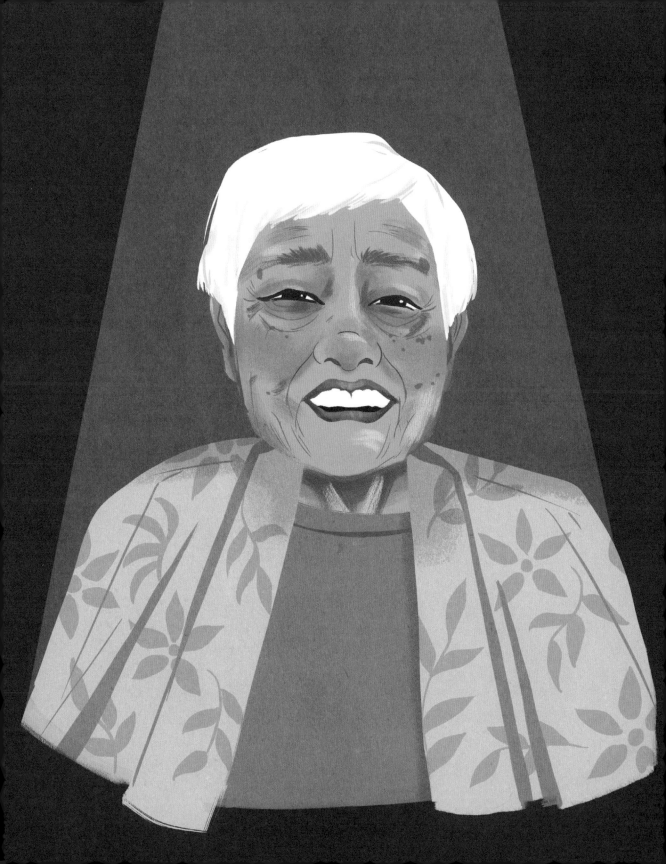

"The only way to survive is by taking care of one another."
— GRACE LEE BOGGS

for forty years." The two helped form the National Organization for an American Revolution and the Detroit Asian Political Alliance. They led with community-focused activism to protest the Vietnam War and organize against the marginalization of the Asian community. She was a key figure in the Asian American movement and heavily involved in the Black Power movement; Boggs was a brilliant writer who saw that the way forward was working together to advance the civil rights of underrepresented people, especially women and BIPOC people. She always made her work intersectional—rooted in the faith that we can only make meaningful changes when we are all represented.

In 1992, the couple founded Detroit Summer, a youth program for BIPOC teens to get involved in their communities by cleaning up streets, turning abandoned lots into community gardens, and creating public art programs to beautify neighborhoods. As she expanded her activism, she came

to focus on community engagement as the only way forward against capitalism—identifying it as the first shackle of racism and oppression. She continued to write newspaper columns and give inspiring interviews about sustainable revolution well into her ninth decade. A PBS documentary was released about her life, *American Revolutionary*, a year before she passed away at the age of one hundred.

"A rebellion is righteous, because it's the protest of a people against injustice."

Kamala Harris

October 20, 1964–

FIRST FEMALE VICE PRESIDENT OF THE UNITED STATES

On a crisp winter morning in Washington, DC, Kamala Harris stands in a regal purple coat over a matching dress, with her signature pearls on in a nod to her Alpha Kappa Alpha sorority. Her husband, the first Second Gentleman, Doug Emhoff, is next to her holding two Bibles of historical significance to her, and Supreme Court Justice Sonia Sotomayor is administering the oath. It's January 20, 2021, and Harris has just become the first female and first Black and Southeast Asian person to be sworn in as vice president of the United States of America. Girls and women of all ages around the world watched her and said, *That can be me.*

Her path to the vice presidency began in Oakland, California, as a daughter of an Indian immigrant doctor and a Jamaican-born professor at Stanford. She was raised attending civil rights protests in her stroller and embracing both her South Asian and Black identities through church, temple, and food. Shortly after graduating from HBCU (Historically Black Colleges and Universities) Howard University and UC Hastings College of Law, Harris began shattering political glass ceilings by becoming San Francisco's first female district attorney, then California's first Black female attorney general, and finally a US senator for California. Harris married Emhoff in 2014, becoming a "Momala" to Emhoff's two kids. She also authored three books and made a presidential bid in 2020 before she became Joe Biden's running mate—and

ultimately, a vice president the United States has never seen before. Of her accomplishments, she often quotes her mother, Shyamala Gopalan: "You may be the first to do many things, but make sure you are not the last."

"That's why breaking those barriers is worth it. As much as anything else, it is also to create that path for those who will come after us."

Patsy Mink

December 6, 1927–September 28, 2002

FIRST WOMAN OF COLOR IN THE US HOUSE OF REPRESENTATIVES

Patsy Mink was a person who turned her struggles into a way to open so many new doors for women, especially underrepresented women. Rejected from a dozen medical schools on the basis of gender, Mink eventually found her way to law school on a lark (they accepted her to fill a "foreign student" quota even though she was third-generation Hawaiian and a US citizen). She then went on to Congress in 1964 to become the first Asian American woman, and by extension the first BIPOC woman, elected to the House of Representatives. She would serve twelve terms representing her home state of Hawaii before her passing in 2002.

Mink's path opened new doors, in part because so many existing paths were closed to her. She became the first Japanese American woman to open her own law firm in Hawaii because no other firm would hire her. In Congress, she became a liberal leader on education, gender and racial equality, and family care. She was one of the few outspoken anti–Vietnam War members of Congress—and she even became the first Asian American woman to run for president on that platform in 1972.

Mink's greatest legacy was co-authoring and cosponsoring Title IX, which banned discrimination on the basis of sex—including assigned sex, gender identity, and transgender status—in academic and athletic institutions receiving federal aid. It passed in 1972, and its impact is clear: in 1971, 8.5 percent of US women twenty-five and older had college degrees compared with 15 percent of men.

In 2020, 38 percent of women have degrees, with men coming in at under 37 percent. That's just a microcosm of the change this law accomplished. When it comes to women in sports, before Title IX, fewer than three hundred thousand girls participated in high school sports, and now 3.5 million do. The rise of women in professional sports—notably, the success of the US Women's National Soccer team—can be traced back to the power of this law.

Mink followed this up with the passing of the Women's Educational Equity Act in 1974, which provided federal funding to prevent gender discrimination in educational programs—like replacing biased textbooks that pushed men toward careers in engineering and medicine and women back into the home. Mink not only broke many barriers in her life, she also created the opportunity for millions of women to break through barriers of their own.

AFTER MINK'S PASSING, TITLE IX WAS RENAMED THE PATSY TAKEMOTO MINK EQUAL OPPORTUNITY IN EDUCATION ACT.

"If to believe in FREEDOM AND EQUALITY is to be radical, then I am a RADICAL."

—PATSY MINK

Shirley Chisholm

November 30, 1924–January 1, 2005

FIRST BLACK WOMAN ELECTED TO US CONGRESS AND TO RUN FOR PRESIDENT

TIMELINE

1929

Since their parents struggled economically and worked factory jobs, Chisholm and her sisters were sent to live with their grandmother, Emaline Seale, in Barbados. With the strength and love of Seale, Chisholm grew up with a great sense of self, stating, "I learned from an early age that I was somebody."

1924

Shirley Chisholm was born in Brooklyn, New York, to immigrant parents of Barbadian and Guyanese descent.

> "I want to be remembered as a woman . . . who dared to be a catalyst of change."

1934

The girls returned to New York. Chisholm got her first taste of politics when her father became a supporter of union advocate Marcus Garvey.

1939

She began attending Girls' High School in Brooklyn, a prestigious integrated school that gave Chisholm her first experience with equal opportunities.

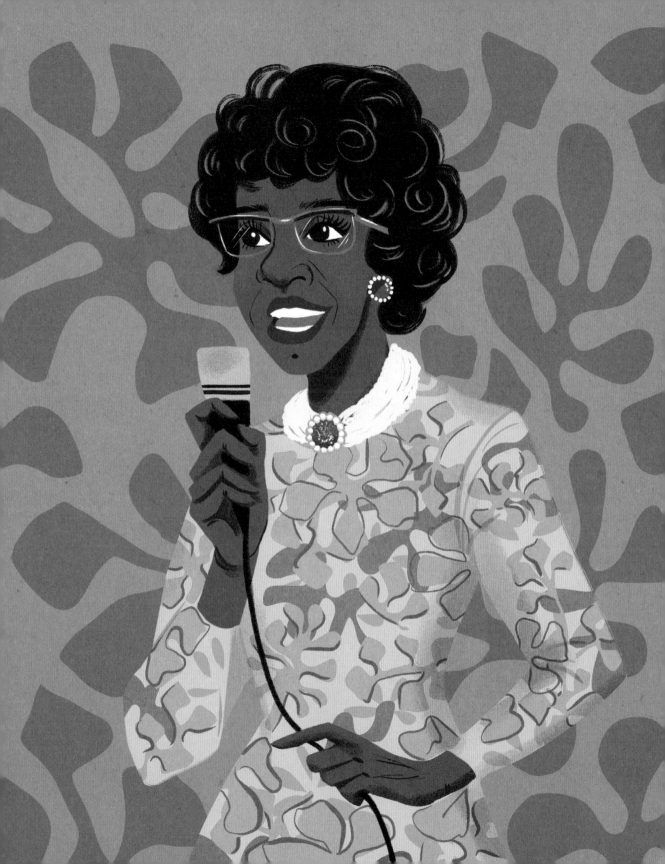

1946

Chisholm graduated with a BA from Brooklyn College. While in school, Chisholm was a part of the Delta Sigma Theta sorority and the Harriet Tubman Society. She became known for her award-winning debate skills and her advocacy for equal rights and representation. Afterward, she also earned a master's degree from Columbia University's Teachers College.

1953

Along with working as a director and consultant for early education centers, Chisholm began her political work in community groups like the Bedford-Stuyvesant Political League and the Unity Democratic Club. Through them, she contributed to electing Lewis Flagg Jr. as Brooklyn's first Black judge and Thomas R. Jones as Brooklyn's second Black assemblyman.

1971

She cofounded the National Women's Political Caucus, the only national membership organization that works to get more pro-choice women into elected and appointed office at all levels of government.

1972

Chisholm became the first Black *and* first female candidate to run for president of the United States in the Democratic Party. Her platform centered on racial and gender equality. Though her campaign was severely underfunded, and she was banned from participating in televised primary debates, Chisholm entered twelve primaries and gained 152 of the delegates' votes. Her campaign colors were yellow and purple (perhaps a nod to both women's suffrage colors and to bipartisanship); they would go on to be symbolic colors for women in politics in the future.

1977

During her tenure as a congresswoman, she was elected Secretary of the House Democratic Caucus and became the first Black woman ever to serve on the House Committee on Rules.

1964

Chisholm ran for a judicial seat despite the Unity Democratic Club's hesitancy to support a female candidate. She won and became a member of the New York State Assembly, where she pushed against literacy tests, created legislation extending unemployment benefits for domestic workers, and sponsored the SEEK program for disadvantaged students, which helped them attend college while supported by remedial education classes.

1968

Chisolm was elected to the US House of Representatives, becoming the first Black woman ever elected to Congress. She hired only women for her office, and more than half of them were Black. Her work on over fifty pieces of legislation focused on food stamp programs, early childhood development, gender equality (she was named honorary co-president of the National Association for the Repeal of Abortion Laws [NARAL] and cofounded the National Organization for Women [NOW]), and increasing the minimum wage.

1980S

Chisolm retired from Congress and moved to suburban Williamsville, New York. But she didn't slow down in retirement. She was appointed to the Purington Chair at Mount Holyoke College and led a broad range of classes on democratic ideals. She traveled to other schools giving speeches and remained politically involved at the local level. With C. Delores Tucker, she also cofounded the National Congress of Black Women.

1993

She was inducted into the National Women's Hall of Fame.

2015

Ten years after her death, President Barack Obama posthumously awarded Chisholm the Presidential Medal of Freedom.

Sonia Sotomayor

June 25, 1954–

FIRST LATINX US SUPREME COURT JUSTICE

In 2009, Sonia Sotomayor became the first Latinx justice appointed to the US Supreme Court. Born and raised in the Bronx projects by two Puerto Rican parents, Sotomayor didn't speak English until after her father passed when she was nine. She originally wanted to be a detective like her hero Nancy Drew, but a type 1 diabetes diagnosis at the age of seven led doctors to suggest a more stable future career to accommodate her new health challenges. When she was a child, diabetes care was much more complicated. For example, disposable needles for insulin shots didn't exist, so she had to wake up early to boil water and sterilize the needles. These responsibilities made her more mature and disciplined at an early age—and she would find a new dream in becoming a judge like the ones she watched on *Perry Mason*. Sotomayor went on to graduate as valedictorian of her private high school class, graduate summa cum laude from Princeton University, and earn a JD from Yale Law School.

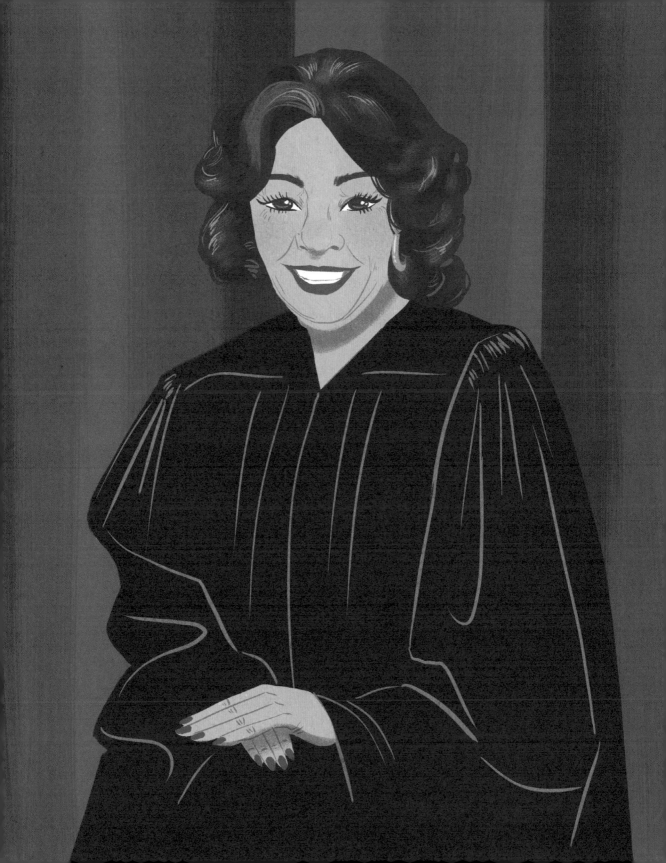

"Remember that no one succeeds alone. Never walk alone in your future paths."

— SONIA SOTOMAYOR

She threw herself into all kinds of legal work, doing everything from working in the Manhattan district attorney's office to commercial litigation and serving on policy boards. In 1992, she became the first Latinx judge appointed to a US District Court, and ultimately ascended to the highest court in the land via a nomination from President Barack Obama.

Despite her incredible credentials, Sotomayor still draws criticism for embracing her personal style that reflects her Latinx roots—wearing red nail polish to her Supreme Court confirmation, and often accessorizing with dangling earrings and gold jewelry. Though she was one of the most politically independent nominees, herself a registered Independent, she has become the voice of the liberal wing of the court, writing more dissents than any other justice since she's been seated. Her focus has largely been on equality. Additionally, she's authored many books (for adults and children) and makes the most public appearances out of all the justices, with the goal of helping more underrepresented youth see themselves in positions of great power and influence.

"We are never going to reach equality in America until we achieve equality in education."

Stacey Abrams

December 9, 1973–

VOTING RIGHTS ADVOCATE

Stacey Abrams is an American political leader, author, and lawyer who was the first woman elected to the Georgia House of Representatives in 2010, and the first Black woman in US history to be a major party nominee for governor. Her tireless work for equal voting rights and fascinating background make her one of the most influential and inspiring leaders in the country.

EARLY LIFE

Abrams is known for many remarkable firsts: She was the first Black valedictorian of her high school, the first woman to lead in the Georgia General Assembly in 2006, and the first Black person elected to lead the Georgia House of Representatives in 2010. She's been facing discrimination since she was a young girl: When her Girl Scout troop leaders picked her to represent their home state of Mississippi at the national conference, some people were unhappy with the selection of a Black girl. They attempted to sabotage her by changing her flight reservations. Abrams flew by herself to the conference anyway.

PROMISING YOUNG WOMAN

When she was seventeen, Abrams was hired as a political speechwriter after working as a typist at a congressional campaign and impressing the committee with the edits she made to their work. She attended HBCU Spelman College, where she started voter registration drives her freshman year. While at Spelman, Abrams challenged Atlanta's first Black mayor, Maynard Jackson, on a televised town hall over social justice issues. She was then hired as a research

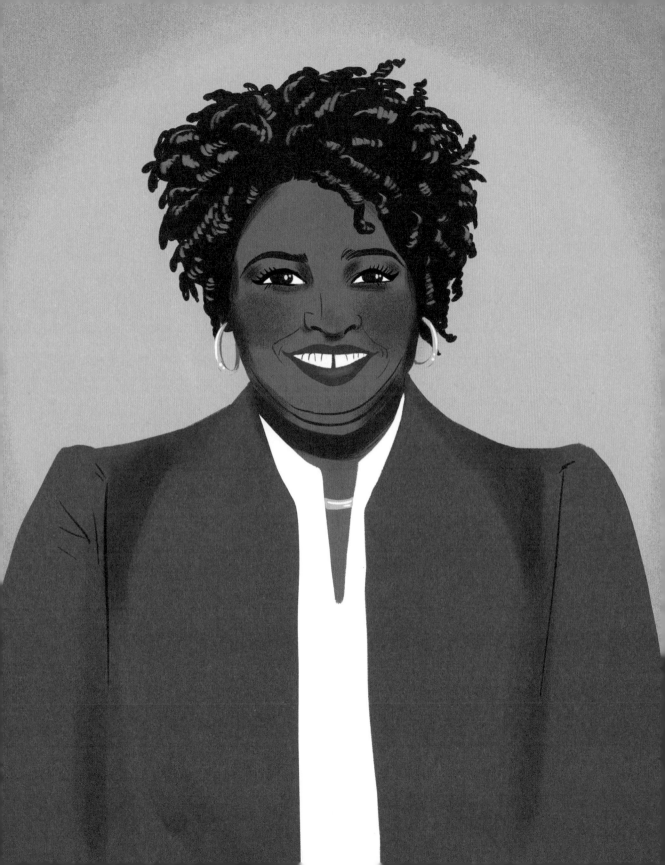

assistant in his Office of Youth Services—as the only undergraduate staff member. She also earned a master of public affairs in public policy from the University of Texas, Austin, and a JD from Yale Law School.

FAIR FIGHT

Abrams started her career as a tax attorney before being appointed to the position of Atlanta's deputy city attorney. In 2018, after losing by less than two points in the Georgia gubernatorial race, one plagued with allegations of voter suppression, Abrams founded Fair Fight Action, a voter protection organization. Between Fair Fight, and her first organization, the New Georgia Project, Abrams and her team have helped register more than one million new and first-time voters, especially voters of color. Fair Fight Action's work in the 2020 elections helped get two Democratic senators elected to represent Georgia, thus flipping the US Senate. The success of turning Georgia blue to help President Joe Biden win that year's election is attributed to the organization.

EXTRA CREDIT

In her third year at Yale Law School, Abrams wrote her first romance novel under the pen name Selena Montgomery. It would be the first of eight romantic suspense novels she has penned as of this writing. She also published two political nonfiction books and a fictional political thriller. If that's not enough, she's also an entrepreneur: Abrams has cofounded two businesses. Nourish, Inc. was a formula-ready water bottle company focused on infants and toddlers, and NOWAccount is a financial services firm for small businesses—which she created out of necessity when running her first business.

"Leadership is about answering that question: How can I help?"

— STACEY ABRAMS

IN PURSUIT OF

Excellence

Ann Lowe

December 14, 1898–February 25, 1981

FASHION DESIGNER TO THE ELITE

One of the first Black fashion designers, Ann Lowe was the best-kept secret of high society. She grew up in Alabama, working with her seamstress mom, Janey, and grandma, Georgia, to create dresses for Montgomery's fashionable elite. Lowe was sixteen when her mom unexpectedly died, and she stepped up to finish the four ball gowns her mother was in the middle of creating for the governor's wife. Years later, after leaving her first husband because he didn't support her career, she moved with her young son to New York, where she enrolled at

S.T. Taylor Design School. Her work was often used as an example of the best work in the school, despite segregationist policies at the university that kept her in a separate classroom.

After building a reputation for her couture levels of craftsmanship and working for years as a private designer of fairy-tale gowns for the elite, Lowe opened her own New York City shop in 1950. In 1953, she was contacted by Janet Lee Auchincloss to create her daughter Jackie's wedding gown and the dresses for her entire bridal party, for Jackie's upcoming marriage to John F. Kennedy. A week before the wedding, a pipe burst in Lowe's studio, damaging all the dresses in progress. Lowe gathered her grit and purchased more fabric, hired extra help, and worked day

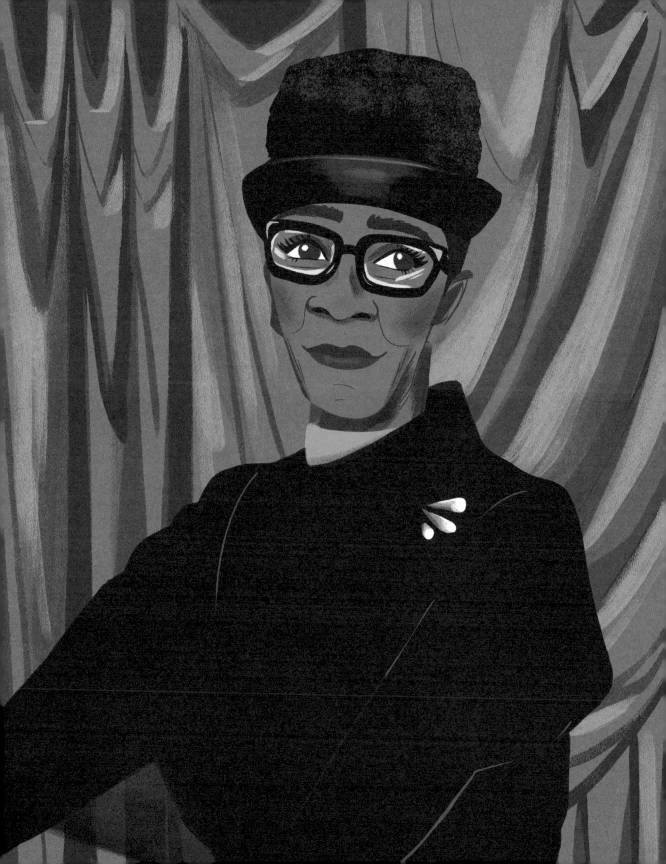

and night to recreate the gowns. When she arrived in Newport, Rhode Island, to deliver the dresses, she was told to use the service entrance in the back—to which she responded, "I'll take the dresses back" if she had to use the rear door—and strode right in through the front.

Even though the wedding gown received tons of publicity, the creator was only addressed as "a colored dressmaker." Lowe would eventually lose her first store because she never made enough of a profit, but she always kept going. In 1961, Lowe received the Couturier of the Year award; in 1968, thanks to an anonymous donor who paid off her debts, she opened a new store. She retired by 1972 and lived with her daughter Ruth in Queens until her death in 1981. Now in history as a member of fashion's elite, Lowe has many pieces in the collections of the Smithsonian, the Metropolitan Museum of Art, the Museum of

the City of New York, and the Museum at the Fashion Institute of Technology.

"I love my clothes, and I'm particular about who wears them."

Joyce Chen

September 14, 1917–August 23, 1994

THE FIRST CHINESE AMERICAN CELEBRITY CHEF

If you love Mandarin Chinese food in America, you have Joyce Chen to thank. Chen was the first Chinese American celebrity chef on television and an entrepreneur with four eponymous restaurants and two kitchen product lines under her apron strings. She was born and raised in Beijing, where she learned to cook from the family cook, and then immigrated to Cambridge, Massachusetts, with her husband and children. Her passion for sharing Chinese food with her new American community began when she made pumpkin cookies and egg rolls for her children's school bake sale. They were a major hit, which encouraged her to introduce even more of her Chinese cuisine. Her restaurants operated for more than forty years and made an impact on the Boston community. A former Harvard president called her locations "not merely a restaurant, but a cultural exchange center."

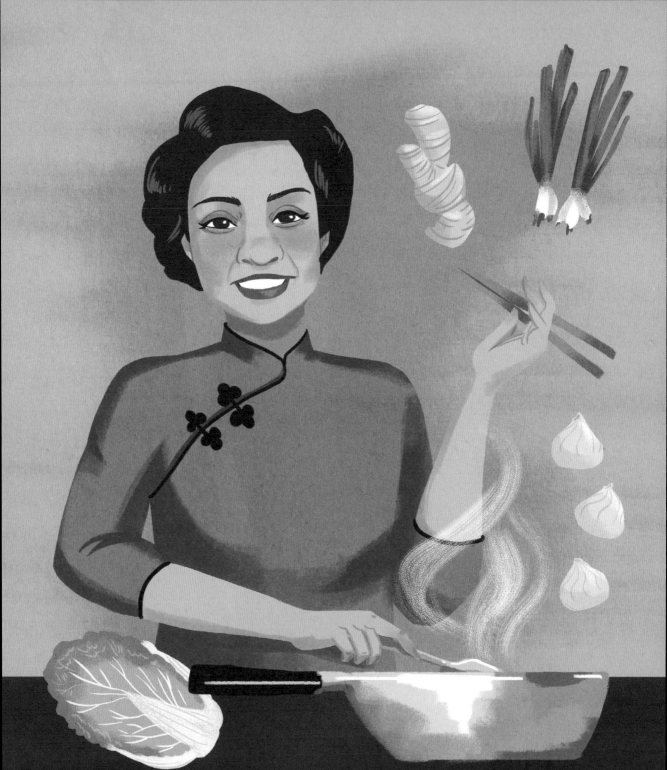

1958

Chen opened her first restaurant, Joyce Chen Restaurant, in Cambridge. There, she introduced the all-you-can-eat Chinese buffet to encourage non-Asian patrons to try more authentic dishes. She also invented the numbered menu that allowed Chinese and non-Chinese patrons and employees to communicate more efficiently. Chen introduced audiences to Mandarin food, including Peking duck, moo shoo pork, hot and sour soup, and potstickers, which she called "Peking Ravioli." The restaurant was a major success, drawing in many students and researchers from MIT and Harvard University.

1962

She self-published the *Joyce Chen Cook Book,* which brought Chinese cooking, ingredients, techniques, and tools into the American home. In it, she made suggestions and adaptations for American kitchens, much of which she discovered on her own since immigrating. She single-handedly sold six thousand copies before a publisher scooped it up. The book would go on to sell an additional seventy thousand copies.

1967

The success of her cookbook led to her own PBS cooking show called *Joyce Chen Cooks*. Along with teaching wide audiences how to cook authentic Chinese food, she also taught them traditions and customs like how to use chopsticks, and introduced them to new kitchen tools like the Chinese vegetable cleaver. She shared a set with Julia Child for her show *The French Chef*, and the two women became good friends. Chen's show ran for twenty-six episodes, making her one of the first non-white television chefs. Due to popular demand, Chen opened her second restaurant: Joyce Chen Small Eatery Place. With this new business, she introduced Americans to the now famous xiao long bao and dim sum.

1969

Joyce Chen Restaurant, a five-hundred-seat establishment, opened. It was Chen's third and largest restaurant. She also started teaching Chinese cooking classes at adult centers in Boston, which gained long wait lists.

1971

Unable to find cookware that fit Chinese cooking, Chen founded Joyce Chen Products and patented a flat-bottom wok that she called the Peking Wok.

1972

United States–China relations changed, and President Nixon visited China for the first time, opening up American interest in the country. The Chen family traveled to China, and Chen's son Stephen filmed the entire trip. They sold the footage to PBS for a special, *Joyce Chen's China*, which aired the following year.

1973

Chen opened her fourth establishment, the upscale Joyce Chen Restaurant, in a custom-designed modernist building secluded behind a garden wall. It operated for twenty-five years.

1982

All about efficiency and making Chinese food elevated yet approachable, Chen started Joyce Chen Specialty Foods. They sold bottled sauces and specialty flavors in grocery stores.

1985

Chen retired and passed the business on to her children. She passed away in 1994.

2014

The US Postal Service released a Joyce Chen stamp in a Celebrity Chefs series.

Maria Tallchief

January 24, 1925–April 11, 2013

AMERICA'S FIRST PRIMA BALLERINA

FROM THE PLAINS OF OKLAHOMA TO THE SHORES OF CALIFORNIA

Elizabeth Marie Tall Chief was born a member of the Osage Nation, where her father came from an affluent oil family. Her Scottish-Irish mother had dreamed of being a performer but came from humble beginnings, so she was set on daughters Elizabeth and Marjorie getting the lessons she never had. Tall Chief was enrolled in dance classes by age three, and the whole family moved to Los Angeles when she was eight so the children could audition for Hollywood musicals. There she trained in dance and piano while struggling through discrimination in Beverly Hills schools. At twelve, she began working with famous Russian ballerina Bronislava Nijinska—who inspired her to become a professional ballerina. Many instructors suggested she change her name to something more "Russian"—but wanting to keep a connection to her Osage heritage, she compromised by changing her name to a version of her birth name: Maria Tallchief. Under Nijinska, Tallchief performed on the Hollywood Bowl stage at fifteen—but in the corps de ballet instead of a lead role, which was initially devastating but pushed her to work even harder.

PASSPORT TO DANCE

Luck is when preparation meets opportunity: Tallchief got her chance to join the Ballet Russe de Monte Carlo, a leading touring company, when they were looking for an extra ballerina who could tour internationally with them. Tallchief was asked because they

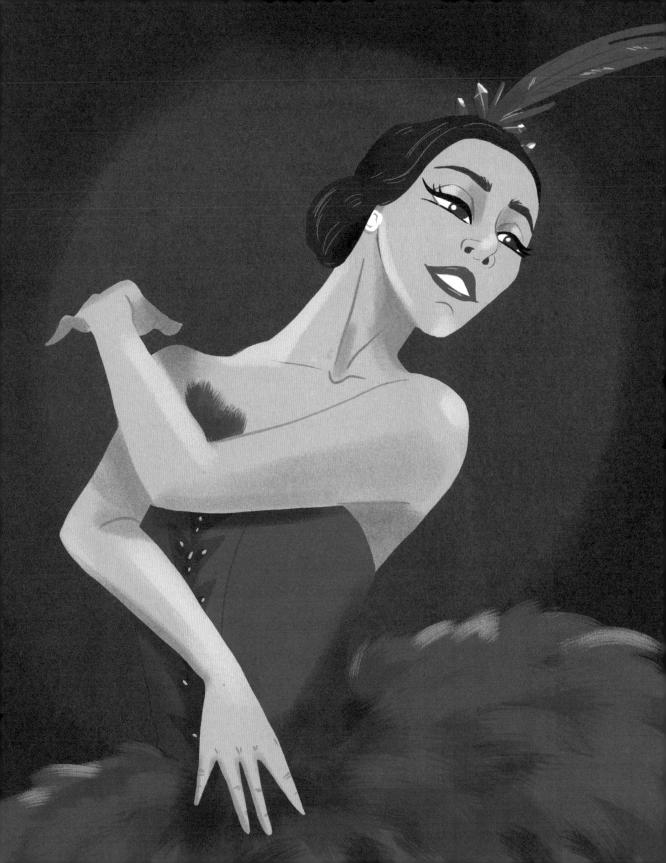

were headed to Canada and she had a passport. She would become an understudy for the lead ballerina and perform with the Ballet Russe for five years, during which time she met choreographer George Balanchine, her future first husband.

BALANCHINE MUSE

Tallchief was Balanchine's muse in the years before and during their marriage, and their partnership, expressed mostly through the stage, took them both to new heights. When Balanchine went to direct the Paris Opéra Ballet, Tallchief joined the cast of *La Baiser de la Fée* and *Apollo*—becoming the first American to perform with the ballet company. Parisians loved her. Her Indigenous background made her a breakthrough figure in a field dominated by Russian and European dancers.

NEW YORK CITY BALLET AND BEYOND

In 1948, the New York City Ballet was formed, and Tallchief became America's first prima ballerina. She was also the first Indigenous person to hold that rank. She danced the lead in *Orpheus, The Firebird,* and *Swan Lake*. She was noted by famous dance critics as revolutionizing ballet; her legacy was popularizing the Sugar Plum Fairy in *The Nutcracker,* then a little-known ballet. She would go on to tour with the Chicago Opera Ballet, the San Francisco Ballet, the Royal Danish Ballet, and the Hamburg Ballet. Her talents would also take her to roles on screens small and large—including playing Anna Pavlova in the 1952 musical film *Million Dollar Mermaid*. In 1954, she returned to touring with the Ballet Russe as the highest-paid prima ballerina at the time.

BEYOND BALLET

In 1953, the Osage Nation gifted her the highest honor by naming her Princess of the Osage Nation and giving her the title Wa-Xthe-Thon-Ba (meaning "Woman of Two Worlds"). Throughout her life, she was proud of her heritage and would continue to speak out against Indigenous stereotypes and be involved with America for Indian Opportunity and the Indian Council Fire Achievement Award. In 1965, Tallchief hung up her pointe shoes and cofounded a ballet school in Chicago with her sister, Marjorie. She received a Kennedy Center Honor and the National Medal of Arts; she was inducted into the National Women's Hall of Fame in 1996.

"Above all, I wanted to be appreciated as a prima ballerina who happened to be a Native American, never as someone who was an American Indian ballerina."

Naomi Osaka

October 16, 1997–

TENNIS CHAMPION SMASHING RECORDS AND EXPECTATIONS

Courage, discipline, and a shy playfulness. These are just a few of the things it takes to be Naomi Osaka. Oh, and a killer 125 mph [200 kph] serve. At twenty years old, Osaka became the number-one-ranked tennis player in the world when she won the final of the 2018 US Open against her idol, Serena Williams, and earned her first Grand Slam win. She also became the first Japanese-born player to do so. Soon after, the young girl who had been trained alongside her sister Mari by their Haitian father Leonard François on free community tennis courts collected three more Grand Slam titles. And she's only getting warmed up.

François and the girls' Japanese mother, Tamaki Osaka, moved their family to a Long Island neighborhood adjacent to Queens—where the US Open tennis stadium is located—in the United States when Naomi was three. Because she was raised in a Haitian Japanese household, her parents made a strategic decision to have her play for her birth country of Japan—which raised her notoriety quickly in a country hungry for tennis stars. Even though there are biracial Japanese people, there's still a major cultural hesitation to see a Black Japanese star represent the country of Japan—and by doing so, Osaka broke down those barriers. Despite her quiet demeanor, she expresses herself through actions about issues she cares about—like flying to Michigan to attend Black Lives Matter marches after George Floyd's murder, wearing the names of Black people murdered by police on her face masks at the US Open, or dropping out of high-profile matches to protect her mental

health. All bold actions for a young, new player, much less one from Japan—a notoriously homogenous country known for its proverb "The nail that sticks up gets hammered down." She's become as famous for her actions off court as for those on court—when she bowed out of one rigorous press conference to protect her own wellness, it opened up the global conversation about athletes and mental health. Her demonstrations of empathy and compassion are signs of true strength—even when she won that 2018 Grand Slam tournament, her first words were a tearful apology to Williams. She's acutely aware of the scrutiny and pressure top athletes face, and she's not willing to give up her own humanity to feed the media frenzy.

"You just gotta keep going and fighting for everything, and one day you'll get to where you want."

The beauty of Osaka's rise is that she is a global star. She represents the future—one of representation and inclusivity. Her success is the success of every multiracial, Black, Asian, and minority person. She shows that you can be strong and soft. And with the world embracing her, and her record-smashing career—in 2020 she became the highest-paid female tennis player in history through her partnerships with brands like Nike, Nissan, Shiseido, and more—she's changing the game for the better.

"Now more than ever I see that you can be more than just one thing. More than just someone who plays tennis."

Portia White

June 24, 1911–February 13, 1968

FIRST BLACK CANADIAN INTERNATIONAL SINGING SENSATION

Portia White was the first Black Canadian concert singer to achieve international success. Raised by Izie Dora and William Andrew White in Nova Scotia as the third of thirteen children, White began her singing career in her church's choir at age six. William, an immigrant and son of formerly enslaved people, was the minister of Cornwallis Street Baptist Church. Izie was the musical director; White and her siblings made up the bulk of the choir. White especially loved singing and eventually took over the choir director role as well as performing on her father's weekly radio program to fundraise for the congregation.

GET TO KNOW PORTIA WHITE

1. In her twenties, White was a schoolteacher at segregated schools, and spent her free time taking formal vocal lessons and competing in singing competitions. She became known for her versatility and diverse repertoire.

2. In 1935, she won the Helen Kennedy Silver Cup at the Halifax Music Festival for the first time—she'd go on to win so many times in later years that the festival organizers just gave her the cup permanently.

3. White made her national debut at Eaton Auditorium in Toronto in 1941, then made her international debut as the first Canadian to perform in New York's Town Hall performance space in 1944. She signed with

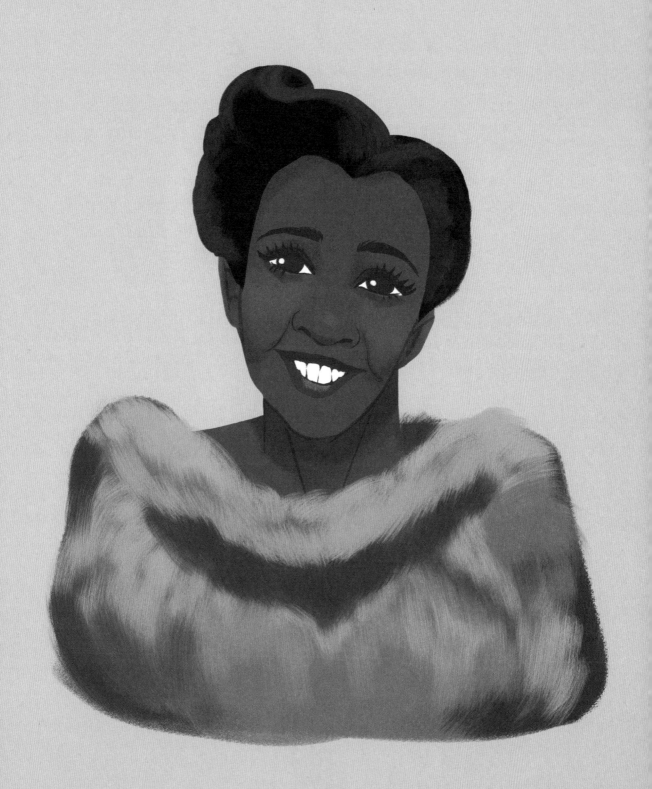

Columbia Concerts in 1945. She was a certified international classical music star.

4. She taught voice lessons to many soon-to-be famous singers, including Lorne Greene, Dinah Christie, and Robert Goulet, to name a few.

5. One of her last public concerts was for Queen Elizabeth II and Prince Philip in Charlottetown, Prince Edward Island, at the Confederation Centre of the Arts in 1964.

6. In 1995, she was posthumously declared a "person of national significance" by the Government of Canada and awarded the lifetime achievement award by the East Coast Music Association.

7. The Nova Scotia Arts Council awards an annual Portia White Prize for an artist who displays cultural and artistic excellence.

"First you Dream. And then you lace up your boots."

—Portia White

Rita Moreno

December 11, 1931–

FIRST LATINX PEGOT WINNER

Puerto Rico–born Rita Moreno is one of three people in the world who've achieved a PEGOT—winning a Peabody, an Emmy, a Grammy, an Oscar, *and* a Tony award. She made her Broadway debut at age thirteen after moving to New York with her mother, and had her Hollywood breakthrough as Anita in 1961's *West Side Story*. She became the first Latinx to win an Oscar for Best Supporting Actress in that role. Even after that achievement, she struggled with being typecast in stereotypical Latinx roles, and she didn't make another film for seven years after her win. Her high standards won out—with a career that spans seven decades and reaches from stage to film to television.

In addition to an illustrious career, she had a sensational romantic life that included tumultuous relationships with Marlon Brando and Elvis Presley before she married her manager, Leonard Gordon, in 1965. She continues to star in award-winning television shows, contribute to disaster relief efforts, engage in civil rights activism, and collect awards—she received the Presidential Medal of Freedom in 2004 from President George W. Bush and the National Medal of Arts in 2009 from President Barack Obama.

"It is through **art** that we will PREVAIL and we will ENDURE. It LIVES ON after us and DEFINES us as people."

— RITA MORENO

RITA MORENO'S PEGOT

1. **PEABODY:** Career Achievement Award

2. **EMMY:** Outstanding Continuing or Single Performance by a Supporting Actress in Variety or Music for *The Muppet Show* (1977) and Outstanding Lead Actress for a Single Appearance in a Drama or Comedy Series for *The Rockford Files* (1978)

3. **GRAMMY:** Best Children's Album for *The Electric Company*

4. **OSCAR:** Best Supporting Actress for *West Side Story*

5. **TONY:** Best Featured Actress in a Play for *The Ritz*

Victoria Draves

December 31, 1924–April 11, 2010

FIRST ASIAN AMERICAN TO WIN AN OLYMPIC GOLD MEDAL

Victoria "Vicki" Manalo Draves made history twice when she became the first woman to win Olympic gold in both platform and springboard diving events, and at the same time became the first Asian American woman to win an Olympic medal. Born in San Francisco to an English mother and Filipino father, Vicki longed to dance ballet but the family was short on funds. Instead, they went to the public pool for the one day a month that non-whites could swim. She learned to swim at ten years old, and she was soon introduced to the world of diving. Even then, she faced daily discrimination at the Fairmont Hotel Swimming and Dive Club where she practiced—a swim coach even insisted she change her last name to her white mother's maiden name, Taylor, in order to be accepted into his school. After discovering a talent for diving, she competed in many national meets before being introduced to her new coach and future husband, Lyle Draves. With his guidance, she qualified for the 1948 London Summer Olympics and won two gold medals with her perfect, seamless swan dive, which sometimes involved one flip (which was very rare at the time). After this history-making performance, Draves toured the world with professional aquatic shows, visited the Philippines, and performed alongside Buster Crabbe, Esther Williams, and Johnny Weissmuller. She was inducted into the International Swimming Hall of Fame in 1969 and would go on to train many young swimmers with her husband. In 2005, the site of her elementary school was turned into Victoria Manalo Draves Park.

IN PURSUIT OF

Exploration

Annie Easley

April 23, 1933–June 25, 2011

NASA ENGINEER AND STEM PIONEER

A pioneer in the STEM (science, technology, engineering, and mathematics) fields, Annie Easley was one of the first Black women who worked at the National Advisory Committee for Aeronautics (NACA, the precursor to NASA). Applying on a whim, she became one of four Black employees out of the 2,500 employees at the Cleveland institution. Easley worked on many projects that continue to make an impact today, especially in alternative energy research.

"My mother always told me, 'You can be anything you want to. It doesn't matter what you look like, what your size is, what your color is. You can be anything you want to, but you do have to work at it.'"

1933

Annie Easley was born in Birmingham, Alabama. Her single mother, Mary Melvina Hoover, told Annie at an early age that if she worked hard, she could be whatever she wanted.

1950

She graduated from high school as valedictorian and enrolled at Xavier University in New Orleans, majoring in pharmacy.

1955

Easley and her husband moved to Cleveland to be closer to his family, but the university there had just closed its pharmacy program. Then she read a local news story about twin sisters working at NACA as computers (a job title at the time for people who performed mathematical equations and calculations by hand). She applied and was hired two weeks later as a mathematician and computer engineer.

1954

Easley married and returned to Birmingham, intending to finish her degree at a different university. She helped people in her community prepare for the literacy test required for Black people to vote under Jim Crow laws.

1958

NACA became NASA (National Aeronautics and Space Administration) when the government decided to focus its talent and budget on space exploration. Easley was one of only four Black employees in the computational department. Her work soon expanded to include space research and running simulations.

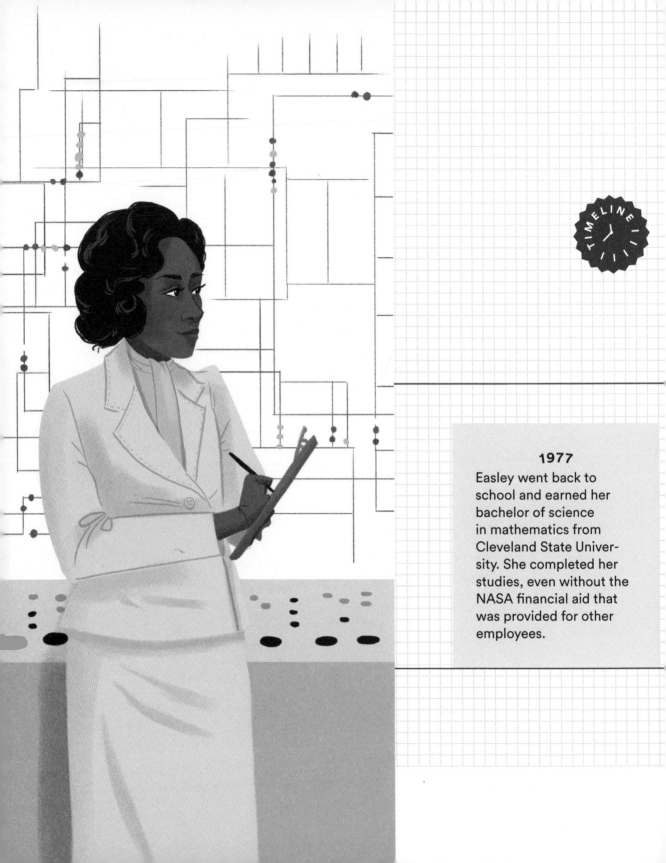

1977
Easley went back to school and earned her bachelor of science in mathematics from Cleveland State University. She completed her studies, even without the NASA financial aid that was provided for other employees.

1970S

Easley started researching and developing code for alternative energy and environmental projects, which included ozone layer damage, solar wind energy conversion, and battery technology that would become integral to early hybrid vehicles. Easley also made a pact with her room supervisor so that they would both wear pantsuits to work on the same day. When they did, it caused a huge stir in the workplace, but also empowered other female coworkers to do the same. One told her, "I was just waiting for the first one to wear pants."

1963

NASA's Centaur program had its first successful launch. Easley had developed code that was used in its upper-stage rocket.

1989

Easley retired and stated that she'd rather be doing something active on the golf course than fiddling with gadgets. She volunteered actively within the community, sold real estate, and traveled the world to ski.

1980S

After finishing her degree, Easley continued at NASA and worked as an Equal Employment Opportunity counselor there, helping create a more equitable workplace while tutoring on the side. Outside of work, she took up skiing at forty-six years old and became the first president of the NASA Ski Club.

Bessie Coleman

January 26, 1892–April 30, 1926

FIRST AMERICAN WOMAN TO EARN AN INTERNATIONAL PILOT'S LICENSE

REACHING FOR THE SKY

Born to Cherokee and Black sharecroppers George and Susan Coleman, Bessie Coleman was the tenth of thirteen children. Coleman started her education at the only Black school in town, 2 miles [3 kilometers] from her home by foot, and earned a scholarship to Missionary Baptist Church School for her stellar math skills. At twenty-three, Coleman moved to Chicago during the Great Migration, when Black people headed north for better opportunities. She landed a job as a manicurist in a barbershop on the Stroll, which was at the crossroads of Black Wall Street and Broadway. Coleman gained a ton of influential clientele and supporters, including Robert S. Abbot, owner of the Black newspaper *Chicago Defender*. In the barbershop, she'd hear stories of female European aviators from World War I veterans, which inspired her to turn her gaze to the sky. When her veteran brother taunted her that Black "women ain't never goin' to fly, not like those women I saw in France," she replied, "That's it, you just called it for me." She found her dream.

BESSIE GOES TO FRANCE

After unsuccessfully trying to find a flight teacher in the United States, Coleman decided to go to France. She took a second job at a chili parlor to save for aviation school, and the community came together to raise funds to support her. In 1920, she boarded the SS *Imperator* for France. She attended the most famous flight school at the time, École d'Aviation des Frères Caudron at Le Crotoy in the Somme, where she learned to fly

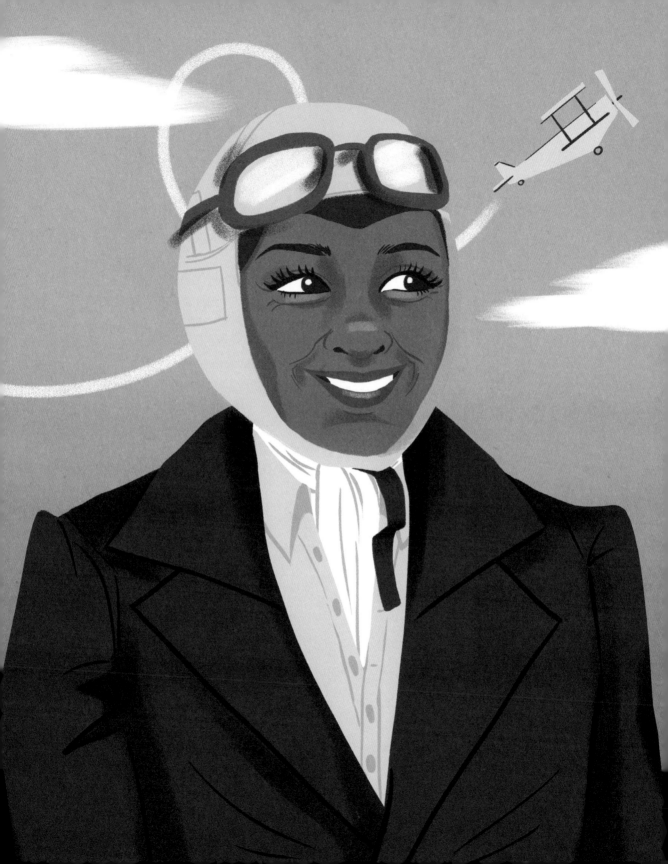

a Nieuport Type 82. She mastered tailspins, banks, and loop-the-loops all in a 27-foot [8-meter] biplane with a 40-foot [12-meter] wingspan. The plane was made of wood, wire, steel, aluminum, cloth, and pressed cardboard—and featured cloth wings prone to peeling. There were no steering wheel or brakes. Instead, a wooden stick controlled the pitch and roll, and a rudder bar helped with vertical elevation. Within seven months, Bessie became the first American woman to earn an international pilot's license. And while her dream was to fly, her real ambition became to open an aviation school for Black people.

BECOMING A BARNSTORMER

After returning to the United States, Coleman began barnstorming across the country in 1922. Many pilots were drawing huge crowds to performances of daredevil feats. She gave her first flight performance in Chicago; she became famous for her figure eights and loop-the-loops. Her celebrity as a pioneer made it easy for her to draw an audience who wanted to see the first Black Indigenous female pilot fly.

"NO UNCLE TOM STUFF FOR ME!"

Coleman used her hard-earned status to take a stand against racism—she refused to perform at shows with segregated entrances, or ones that were whites only. When offered a motion picture deal of her life, she walked out on the production when she saw the script depicting her in a derogatory way. "No Uncle Tom stuff for me!" she declared.

QUEEN BESS

Despite witnessing many deaths among her fellow pilots, Coleman was undeterred in her goal of opening up the sky for her community. In addition to performing to raise funds for her own flight school, she traveled across the country in 1923, giving lectures about her career and registering students. A flight accident would

ground her for two years before she returned to Texas for a grand comeback show on May 1, 1925. Tragedy struck during her rehearsal flight, when a faulty plane caused the ultimate demise of Coleman and her copilot William Wills. Her impact was truly felt after her untimely loss. More than fifteen thousand mourners paid their respects in Texas and Chicago. To this day, women still make up only 7 percent of American pilots, but Coleman's ambition to reach for the sky inspires the dreamer in all of us.

"I refused to take no for an answer."

Bessie Stringfield

1911 or 1912–February 16, 1993

THE MOTORCYCLE QUEEN OF MIAMI

A woman as mythical as her origin story, Bessie Stringfield fearlessly rode her motorcycle solo eight times across the lower forty-eight. She often told different stories about her parents, her birthplace, and birth year. While no one can really pin down her roots, everyone should know her legacy.

Stringfield got her start in the 1920s, performing carnival stunt shows and riding races to earn money. When carnivals found out she was a woman, they often refused her rightful prize money. Undeterred, Stringfield kept at it—because she loved it. She was fueled by passion and wanderlust, following her heart wherever it led her across the country. Even though the times were dangerous in the Jim Crow South, Stringfield was brave and determined and refused to give up her calling simply due to the injustice of society. She wanted to ride, so she did.

Her trailblazing life continues to inspire female riders today: There's an annual all-female charity ride held in her honor every year. In 2000, the American Motorcyclist Association created the Bessie Stringfield Award, and in 2002, she was inducted into the Motorcycle Hall of Fame.

A LOVER OF DOGS, SHE HAD TWO POODLES WHO OFTEN PERFORMED WITH HER ON HER BIKE—SABU AND RODNEY.

GET TO KNOW BESSIE STRINGFIELD

1. She taught herself to ride her first motorcycle at the age of sixteen. Her first bike was a 1928 Indian Scout, a gift from her adoptive mother.

2. To decide where she would travel next, Stringfield would flip a coin over a map. She rode across the country solo, before there was even an interstate highway system, relying on the kindness of Black families she met along the way for places to stay. If there were none, she slept on her bike near a gas station.

3. During World War II, Stringfield served as a civilian motorcycle dispatcher for the US Army, carrying documents from base to base as the only woman in her unit.

4. When she arrived in Miami in the 1950s, the police gave her a hard time for riding a motorcycle as a Black woman. She claimed that once she demonstrated her riding skills to the police captain, he gave her a license to ride and left her alone after that.

5. As she became more experienced, her preferred bike was a Harley-Davidson. She would go on to own twenty-seven bikes throughout her life. Her favorite bike color was blue.

6. When her doctor advised her to stop riding on account of her enlarged heart, Stringfield told him, "If I don't ride, I won't live long." She continued to ride long into old age, passing peacefully at eighty-two.

"When I was in high school I wanted a motorcycle. And even though good girls didn't ride motorcycles, I got one."

—BESSIE STRINGFIELD

Hazel Ying Lee

August 25, 1912–November 25, 1944

FIRST ASIAN AMERICAN WOMAN TO BECOME AN AIRFORCE PILOT

Hazel Ying Lee blazed a trail in the sky when she became the first Chinese American woman to join the US military's Women Airforce Service Pilots (WASP). Remembered by many of her friends and peers as being bubbly, bright, and willing to take on any job, Lee was a leader among her team. She was bold and fearless—many recount an emergency plane landing she made in a Kansas field and how she was chased by a farmer with a pitchfork, shouting that the Japanese were invading, until she demanded he stop and he did. She was also known for writing her and her friends' planes' names on the tails with lipstick. Overcoming both internal and external community biases, Lee forged her own unique path, and her legacy would be recognized posthumously. President Jimmy Carter gave the WASPs veteran status in 1977, and President Barack Obama presented the WASPs with the Congressional Gold Medal in 2010.

1912

Lee was born in Portland, Oregon. She was one of eight children of Lee Yuet, a businessman, and Wong Sau Lan, a homemaker.

1929

After graduating from high school, Lee got a job as an elevator operator at a department store—one of the few jobs available to Chinese Americans.

1932

At an airshow, Lee took her first airplane ride and fell in love. Despite opposition from her mom, she joined the Chinese Flying Club of Portland and took lessons with famed pilot Al Greenwood. By October, she became one of the first Chinese American women to receive a pilot's license.

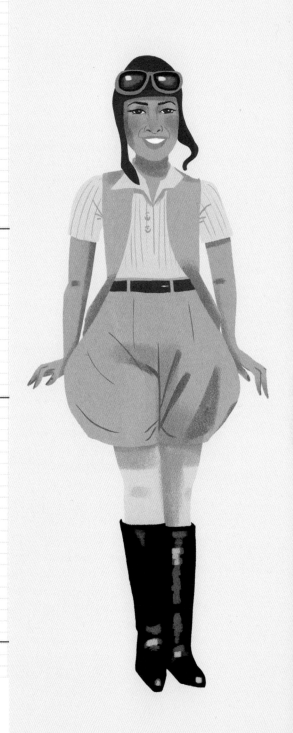

1933

Hoping to fly for the Chinese like her future husband, Louie Yim-qun, Lee went to China to join the Chinese Air Force. However, the Chinese government deemed women too "unstable" to fly, and she was relegated to a desk job and flying commercial jets.

1937

When Japan invaded China, Lee helped save hundreds of fellow civilians in Canton by finding them shelter during the air bombing raids.

1943

The US military formed WASP, headed by renowned aviation pioneer Jacqueline Cochran, to help sustain the war effort at home. Hearing of WASP, Lee headed to Sweetwater, Texas, to sign up for the six-month training program. WASP pilots were often assigned the least desirable tasks—winter deliveries in open cockpit airplanes, flying in the dark, and piloting new planes to their destinations (often discovering manufacturing mistakes midair). They were also considered civilians and paid through the civil service instead of getting military benefits—they even had to pay for their own room, board, and uniforms. But the women loved to fly, and this was one of the few opportunities they had.

1944

Lee received intensive training to fly "pursuit" planes—faster, higher-powered fighter planes, including her personal favorite, the P-51 Mustang. She was sent to New York to deliver a P-63 Kingcobra plane to Montana. During the landing, Hazel's plane collided with another P-63. She passed away two days later from the injuries she sustained. The WASP program ended a month later.

Kalpana Chawla

March 17, 1962–February 1, 2003

FIRST INDIAN AMERICAN WOMAN IN SPACE

Kalpana Chawla was the first Indian American woman in space, flying her first mission on November 19, 1997, as part of the Space Shuttle Columbia crew flight STS-87. That's pretty far for a girl from Haryana, India, who fell in love with flight when she spotted a plane overhead from the roof of her home. Her father took her to flying clubs to watch more planes; she would even spend her free time in class making paper airplanes.

After graduating with a bachelor of engineering from Punjab Engineering College, Chawla moved to the United States in 1982 and pursued a master of science and then a PhD in aerospace engineering. In 1988, she joined NASA's Ames Research Center and contributed to many technical journals. She also received her commercial pilot's

license and became a certified flight instructor. In 1995, she was accepted into the NASA Astronaut Corps, where she trained for a year before her first flight. Chawla was passionate about girls' education, since so few get the opportunity in India, and in 1998, she created a program that sent two kids from India to NASA every year.

On her first mission to space, Chawla said the experience of being weightless was feeling distilled to "just . . . your intelligence." She made 252 orbits around the Earth, logging more than fifteen days in space, and worked on deploying the Spartan Satellite. On January 16, 2003, she boarded her ill-fated second flight back to space with the crew STS-107 on space shuttle *Columbia*. During this mission, Chawla sent what became her final message to the

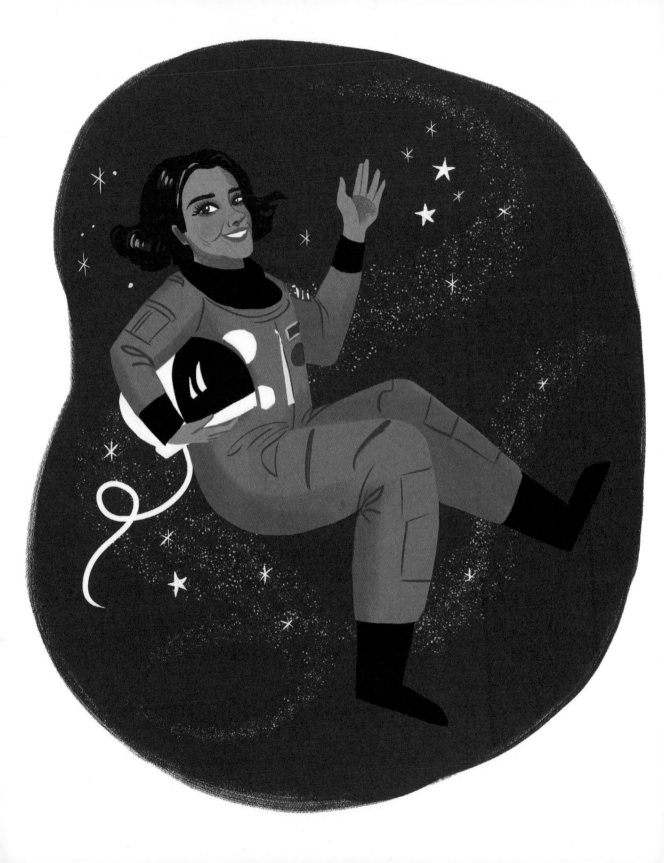

students at her alma mater in Chandigarh, India: "The path from dreams to success does exist. May you have the vision to find it, the courage to get onto it. Wishing you a great journey." The shuttle then experienced fatal damage upon reentry. All seven crew members on board passed away in the *Columbia* disaster on February 1, 2003. Her impact continues to be remembered throughout the world as many spacecrafts and NASA technology programs are named after her, and her passion for girls' education is honored through awards and scholarships.

"When you look at the stars and the galaxy, you feel that you are not just from any particular piece of land, but from the solar system."

Mae Jemison

October 17, 1956–

ASTRONAUT AND AMBASSADOR FOR SPACE TRAVEL AND SCIENCE RESEARCH

Even though Mae Jemison is most noted for being the first Black woman in space, her career has spanned so much more than that *Endeavour* flight she took in 1992 with NASA. Growing up in Chicago, Jemison was inspired by *Star Trek*'s Lieutenant Uhura to become an astronaut. She explained: "Images show us possibilities . . . a lot of times, fantasy is what gets us through to reality." Ambitious and wise beyond her years, Jemison attended Stanford University at the age of sixteen. There, she experienced sexist and racist treatment from professors that would inform her future passion for intersectional concerns in technology and scientific advancement. She went on to study at Cornell University medical school, work at a Cambodian refugee camp in Thailand and with the Peace Corps in Liberia and Sierra Leone, and develop vaccines at the Center for Disease Control and Prevention.

On Jemison's first and only trip to space, she brought along an Alvin Ailey American Dance Theater poster, a photo of Bessie Coleman, a Michael Jordan jersey, and a West African statuette—fully aware of the magnitude of her achievement. She spoke later about feeling excited and happy during the flight, enjoying seeing the sun and Earth from a different perspective. A lover of dance, she even took advantage of the weightlessness to do broad leaps and spins when dancing in space during her free time. While on the 190-hour trip, she worked with Japanese astronaut Mamoru Mohri to conduct science and materials experiments that would fuel her interests post-NASA.

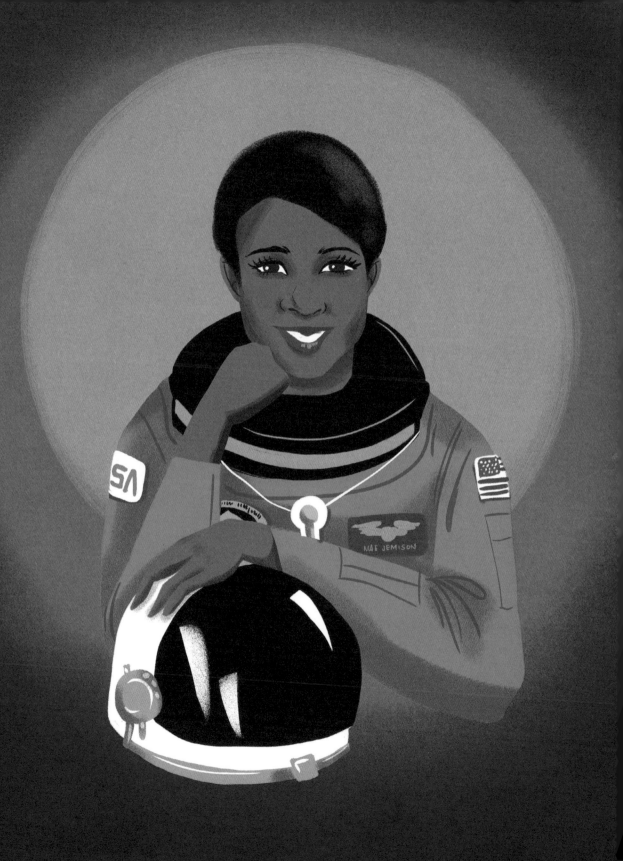

In 1993, Jemison left NASA to start her own companies, the Jemison Group and the Dorothy Jemison Foundation for Excellence (named after her mother)—both of which work on the future of technology and medical advancements. This includes international science camps for students ages twelve through sixteen; the development of BioSentient Corporation, which commercializes medical techniques she experimented with in space; and the 100 Year Starship project, which is developing the foundation for interstellar flight. She's written children's books and starred in an episode of *Star Trek: The Next Generation*. Most importantly, she continues to be a figure of endless possibilities whom young people can see as a regular fixture in academia, science, and space. She's made her broad scope of interests into a lifelong career that has touched thousands of lives.

"Never be limited by other people's imaginations."

Mary Golda Ross

August 9, 1908–April 29, 2008

ROCKET SCIENTIST WHO HELPED TAKE US TO THE MOON

Mary Golda Ross was born in Park Hill, Oklahoma, the great-great-granddaughter of Cherokee Chief John Ross, who led the Cherokee Nation on the Trail of Tears. She had an early love of math that spurred her to seize educational opportunities few women had at the time. Through her passion, she made a career that was so unexpected and trailblazing that she even stumped panelists on an episode of *What's My Line* in 1958. At the time, no one could picture an Indigenous woman as a rocket scientist—and now, thanks to Ross, they do.

> "I was brought up in the Cherokee tradition of equal education for boys and girls."

1920S

Ross graduated from high school at sixteen and then earned a BA in mathematics from the Cherokee Female Seminary (later renamed the Northeastern State Teacher's College), the first women's institution of higher education west of the Mississippi. Her love for math often led her to be the only girl in class, which she never minded. She'd even call her professors late at night with solutions to math problems.

1930S

During summer breaks from teaching math and science in rural Oklahoma public schools, Ross earned a master's degree from Colorado State Teacher's College. Fascinated with space, she took every astronomy class available and read as much as she could about stars.

1942

Ross moved to California for better work opportunities. There she was hired as a mathematician by Lockheed Aircraft Corporation to work on the P-38 Lightning, a fighter airplane that was close to breaking the sound barrier.

1949

Ross received her first professional classification as mechanical engineer (there was no classification for aeronautical engineering at the time). She became Lockheed's first female engineer.

> "Math was more fun than anything else. It was always a game to me."

1953

She was recruited for Lockheed Martin's top-secret project, Skunk Works, the only woman in a group of forty elite engineers. They worked on ballistic missile systems that eventually led to the development of the first Agena rocket, the forerunner of the Apollo program. Ross also cofounded the Los Angeles division of the Society of Women Engineers and started mentoring up-and-coming female engineers.

1958

The space race began: Ross was promoted to research specialist, researching missile and satellite systems for military and civilian missions. Often cited as one of the top engineers in the crew by her peers, she did most of her work with a slide rule and a Friden computer, essentially working by hand compared with the standards of modern technology. All of this work was classified, much of it even to this day.

1983

After her retirement, Ross reconnected with her Cherokee roots. She became a part of the American Indian Science and Engineering Society and the Council of Energy Resource Tribes when they honored her with lifetime memberships and achievement awards. She spent the rest of her retirement mentoring women and Indigenous people entering the engineering field.

1960S

Ross became a fundamental part of the journey to space: She worked on plans for missions to Mars and Venus, created preliminary designs for orbit space systems, and helped write NASA's *Planetary Flight Handbook, Vol. 3,* which was used up to the year 2000. When Neil Armstrong became the first man to walk on the moon, Ross felt pride knowing that "a Cherokee woman from Park Hill, Oklahoma, helped put a man on the moon."

When Ross retired in 1973, there were one hundred female engineers at Lockheed—there were twenty-five women total working at Lockheed in 1959.

2004

Ross attended the opening ceremonies of the Smithsonian Museum of the American Indian in Washington, DC, in her first traditional Cherokee dress, a green calico one made by her niece. She was a part of the largest known procession of Indigenous American communities—twenty-five thousand people participated. A mural was unveiled there that celebrates her legacy.

2008

Ross passed away just three months before her one hundredth birthday at her home in Los Altos, California. She bequeathed a $400,000 endowment to the Museum of the American Indian to continue preserving the legacy of Native people.

IN PURSUIT OF

Expression

Anna Sui

August 4, 1964–

IT GIRL FASHION FOR EVERYONE

After being a flower girl at her aunt's wedding at the age of four, Anna Sui told her Chinese immigrant parents that she wanted to be a fashion designer and began creating her own clothes. At eighteen, Sui made her way to Parsons School of Design in New York City, where she became fast friends with soon-to-be famed fashion photographer Steven Meisel. She worked for several fashion labels after graduation but was eventually fired for simultaneously launching her own home-sewn designs with a department store. But a fateful meeting with Madonna, organized by Meisel, cemented Sui's path to the runway. Madonna wore one of her designs on the cover of *Vogue*. There was no turning back.

In 1991, Sui held her first fashion show with the support of her supermodel friends Naomi Campbell, Christy Turlington, and Linda Evangelista. Heavily influenced by rock 'n' roll and vintage flea market finds, Sui created a line that was whimsical, fresh, and punk at the same time—exactly what It girls and rock stars wanted to wear. She dressed musicians she dreamed of meeting as a student—CBGB (a famous New York punk rock club) regular Dave Navarro walked her runway show in 1997 wearing one of her trendy lingerie-inspired pieces—and she became close friends with her childhood idol, style icon and Rolling Stones muse Anita Pallenberg.

Now in the fourth decade of her brand, Sui's business savvy is only matched by her endless spring of cool-girl inspiration. Her fashion line is buoyed by not only the runway, but also by endless licensing partnerships with everyone

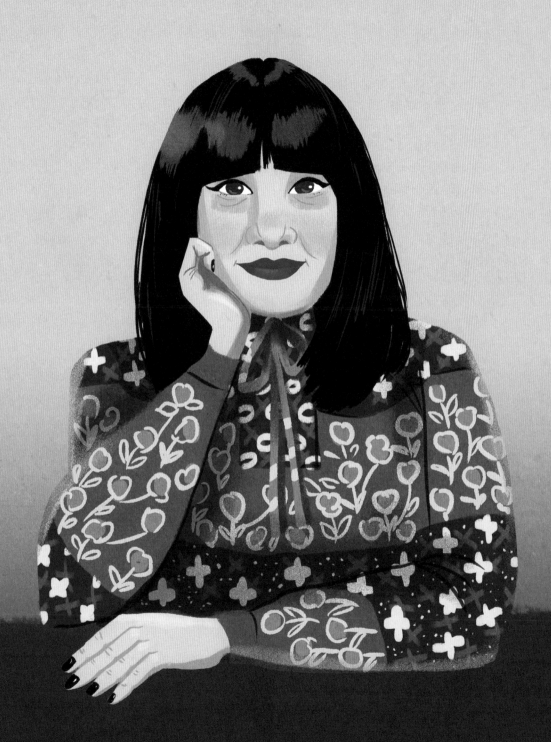

from Starbucks to Target to Teva across North America and Asia. She's one of the only Asian American fashion designers who started in the '80s, and she continues to weave together a punk sensibility with deep art history roots, always with a wink.

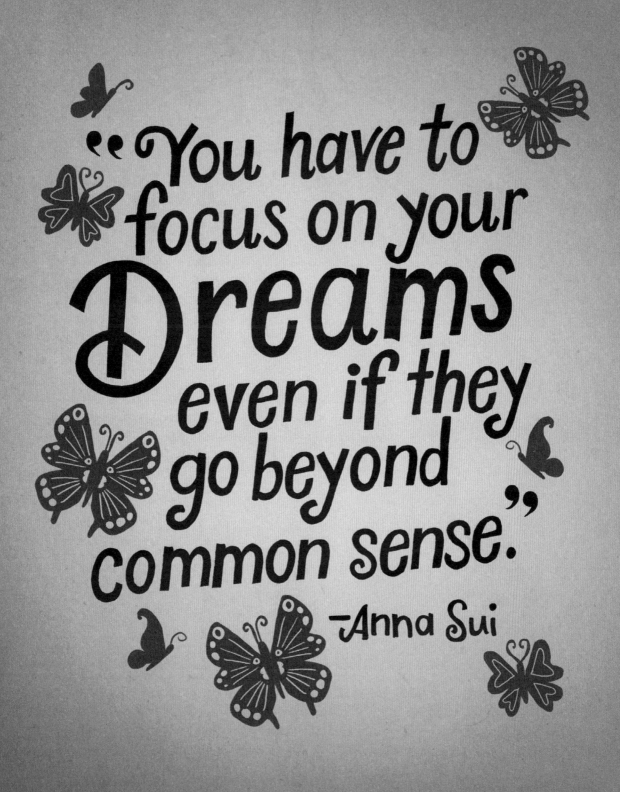

"You have to focus on your **Dreams** even if they go beyond common sense."

—Anna Sui

Carmen Rupe

October 10, 1936–December 14, 2011

MĀORI DRAG QUEEN AND TRANS RIGHTS ACTIVIST

1936

Carmen Rupe was born in native Māori land, Waim-iha, New Zealand. She and her extended family all lived together and off the land with their tribe. Rupe's koro (grandfather) was a respected tohunga (priest), and her kuia (grandmother) was an expert korowai (cloak) weaver. At an early age, she knew she loved dressing up, performing, and boys.

1951

Rupe performed in her first hula show dressed as a woman. Shortly after the performance, she left school to work.

1953

Rupe moved to Auckland where she discovered a "camp"—code word for homosexual—social scene and drag queens.

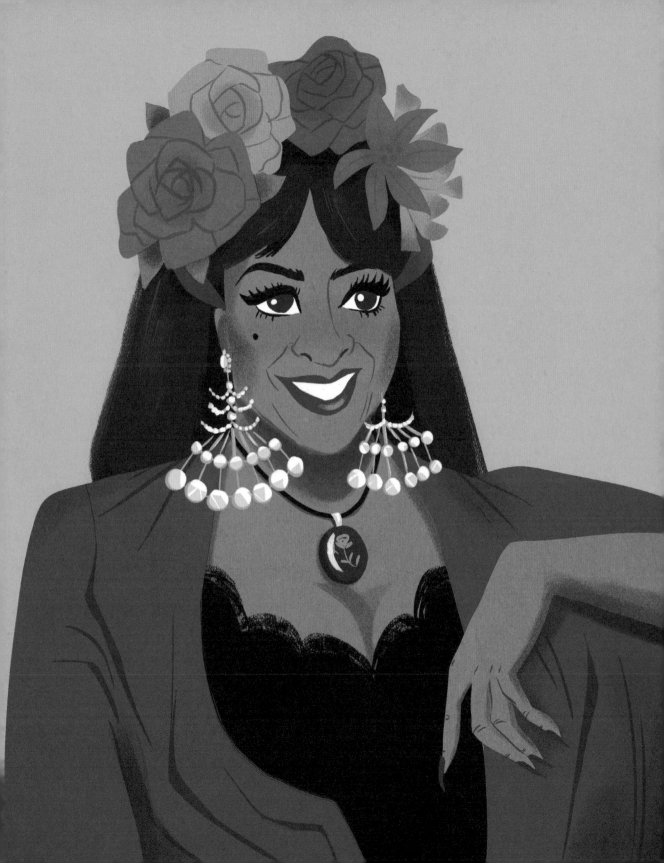

1956

At twenty-one, Rupe pursued her ambition of becoming a nurse during her required military service and trained in the medical corps. Toward the end of her service, she performed in a comedy sketch in semi-drag for the first time. She also began her transition with hormone therapy.

1957

Rupe found work as an orderly at Cornwall Hospital and began dressing as a woman in public. After meeting an English businessman, she also dipped a toe into sex work, which introduced her to a life of travel and luxury. She adopted the name Rupe, inspired by the Hollywood actresses she loved in childhood.

1959

She moved to Sydney after her mother's death and began waiting tables, performing in drag clubs, and seeking out sex work. It's there she also experienced her first brushes with police brutality and violence in the community.

1960s

Despite multiple run-ins with the police during this decade, Rupe also achieved some of her greatest triumphs. She received an inheritance that allowed her to open a boarding house and transition to living full-time as a woman, even legally changing her name to Carmen Tione Rupe. One of her arrests led to a judge ruling that it was not illegal for men to dress as women, and the case was dismissed—a huge win for the trans community. In 1967, Rupe opened her own business, Carmen's International Coffee Lounge, in Wellington. It was a late-night café and underground sex venue where customers could arrange their coffee cups to indicate their preferences for encounters. It became a sensation, a home for those who had none and a place where everyone was welcomed. Her success with the Coffee Lounge led to her opening several other coffee lounges and a nightclub, Le Balcon, which became famous for its glamorous atmosphere and lavish performances.

"As soon as I heard about the drag shows opening there I said 'bye-bye men's clothes.' I've never put anything on since. Never."

MID-1970S

Rupe used her fame to become an outspoken advocate for trans and gay rights, expanding body politics, and decriminalizing abortion. She even ran for mayor of Wellington in 1977, with the campaign slogan "Get in behind!" Her platform included legalizing sex work, abortions, homosexuality, and nude beaches—all initiatives that would eventually become New Zealand law.

1979

The lease was done at Le Balcon, and Rupe decided to close up shop and return to Sydney. She was crowned Queen of Wellington and feted at a farewell ball hosted by her friends at the Majestic Cabaret.

1980S–2011

Upon her return to Sydney, Rupe occasionally guest-performed at nightclubs and returned to sex work. She attended New Zealand's first transgender conference in the early 2000s and became a celebrated matriarch in the community. She managed a community center that supported homeless and vulnerable folks, and advocated for safe sex, HIV/AIDS education, and LGBTQIA+ rights. When she passed in 2011 at the age of seventy-five, her image was installed on Wellington's Cuba Street, the creative heart of the city, to celebrate the thirtieth anniversary of the Homosexual Law Reform Act 1986, and her portrait was installed in the New Zealand Portrait Gallery—the first of a transgender woman.

Celia Cruz

October 21, 1925–July 16, 2003

THE QUEEN OF SALSA

Joyful, sparkling, and commanding, Celia Cruz was a magnetic singer from Cuba who brought salsa music into the mainstream with a career that spanned more than sixty years. Born the oldest of fourteen children in Havana, Cruz won multiple local singing contests and headlined at the famed Tropicana nightclub before joining the band Sonora Matancera as their first Black frontwoman. She was one of the first women to break through in the male-dominated salsa music space. Invitations to perform internationally after the Cuban Revolution led to her being exiled by the Castro regime; Cruz then settled in New York with her husband and fellow band member, Pedro Knight.

In 1965, Cruz went solo. With her fabulous costumes, crackling catchphrase "Azúcar!", and unique blend of Afro-Latinx flair, Cruz became a megastar. She'd go on to collaborate on albums with Tito Puente, Willie Colón, and the Fania All-Stars. She signed with Fania Records, which was responsible for the salsa explosion of the late 1960s through 1970s. Though she wasn't allowed to return to Cuba in her lifetime, not even to bury her mother in 1962, Cruz did find her way back to her homeland to perform at the US naval base at Guantánamo Bay in 1990. From there, she brought back a bag of Cuban earth that she requested to be buried with upon her death—her wish was fulfilled in 2003. Nearly ten thousand fans attended her wake in Miami.

Throughout her life, she made thirty-seven studio albums, many going gold or platinum, and appeared in films like *The Mambo*

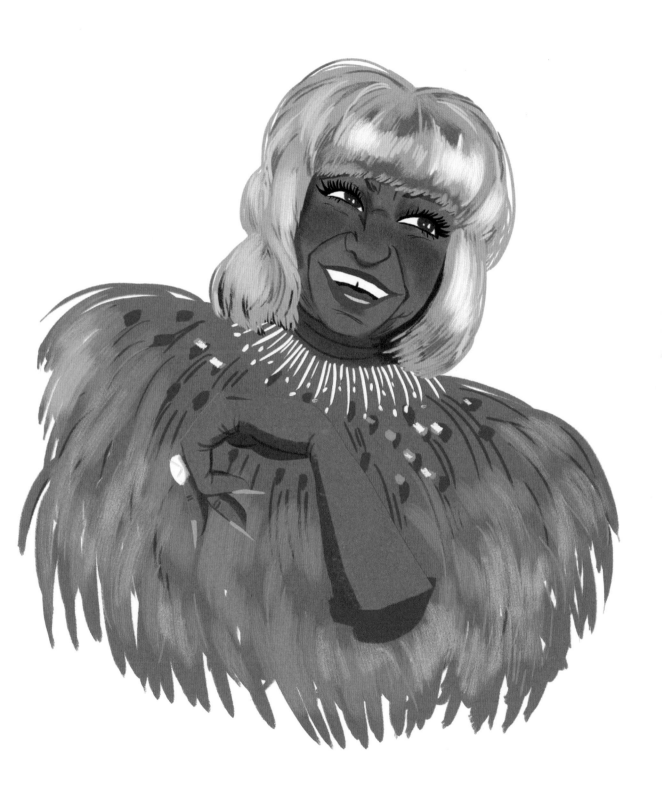

Kings. Cruz won three Grammy awards and four Latin Grammys, and was given the National Medal of Arts, the highest US government recognition given to an artist, by President Bill Clinton. Her flamboyant costumes are part of the Smithsonian's collection in Washington, DC; an off-Broadway musical was made based on her life; and her influence on young musicians, especially Latinx ones, is still felt to this day.

"¡Azúcar!"

Isabel Allende

August 2, 1942–

WORLD'S BESTSELLING SPANISH-LANGUAGE AUTHOR

"I'm not vulnerable because of the truth I tell, only because of the secrets I keep."

With twenty-four (and counting) fiction and nonfiction books published, translations in more than forty-two languages, and more than seventy-five million copies sold, Isabel Allende is the bestselling Spanish-language author in the world. She also worked as a journalist at a feminist magazine, a TV host, and a school administrator before becoming an author at age thirty-nine.

Raised in Chile by a single mother and married at twenty to her first husband, Allende lived in exile in Venezuela for thirteen years— during which time she raised two children and wrote her debut novel, *The House of the Spirits* (1982). The manuscript began as a letter to her dying grandfather. The success of her first book opened a door for her and many more female writers to be published. Her often magical realist work would continue to break barriers for women, especially in Latin-American and Spanish-speaking cultures, by touching on themes of historical events, grief, social issues, politics, justice, and loyalty from a female perspective.

(On feminism) "You don't like the word, don't use it. Change it. It doesn't matter. Just do the work."

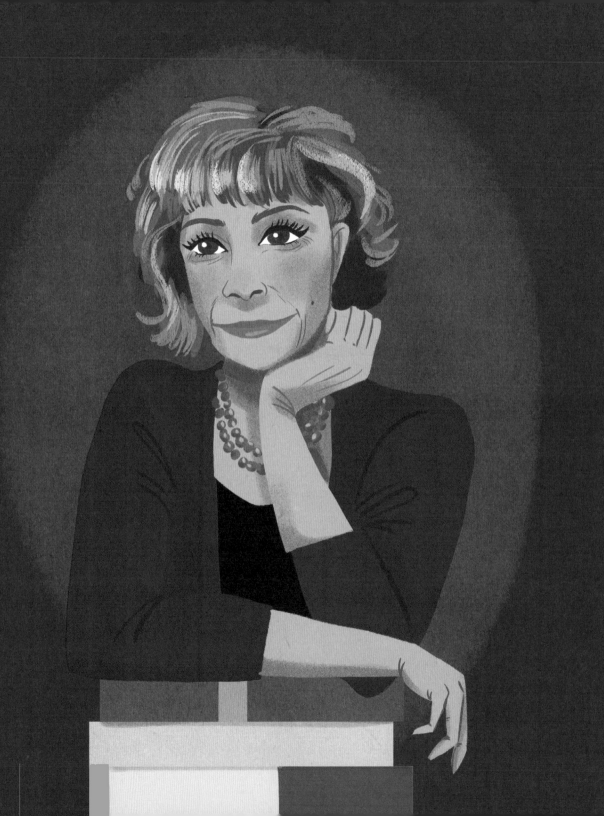

"TALK TO EACH OTHER. WOMEN ALONE ARE VULNERABLE, WOMEN Together ARE INVINCIBLE."

— ISABEL ALLENDE

She often states that her work was a way to deal with the tragic, painful experiences of her life—and to spin them into gold. One especially poignant work is the nonfiction *Paula*, a memoir on losing her twenty-nine-year-old daughter to a rare disease. She took the proceeds from *Paula* to create the Isabel Allende Foundation, which helps women and girls around the world gain access to healthcare, education, economic independence, and means of escape from violence.

Allende moved to California in 1989 with her second husband and became a US citizen in 1993. She has taught writing at multiple colleges and is a winner of countless awards, most notably receiving the Chilean National Literature Prize in 2010 and the US Presidential Medal of Freedom in 2014. She starts working on every new book on January 8, the same date she began writing her first book.

"I've never tried to assimilate to the point of leaving behind my culture, my language, the way I look. I think that I can have everything. Why should I have less? I have more. It's good to be bicultural."

Sandra Oh

July 20, 1971–

ACTRESS WHO SMASHED HOLLYWOOD STEREOTYPES

In 2018, Canadian-born Sandra Oh became the first actor of Asian descent to be nominated for a Best Lead Actress Emmy award for her work on *Killing Eve.* It was her first lead role on television, despite a decades-long career that began in a small town in Canada. Growing up just outside of Ottawa, Oh was a middle child of Korean immigrant parents who didn't see acting as a viable career choice—until she made them. She began working professionally at fifteen, landing leading roles on stage, television, and film all before she turned twenty-one. Her dedication to her craft led her to Hollywood for bigger roles, but she was slapped by harsh reality when an agent told her to go home and get famous there because there were no roles for Asian actors in Hollywood. This would affect her so deeply that when she was asked to read for *Killing Eve*, she didn't even realize that they were asking her to be the lead. It had become so normalized not to have East Asian women and BIPOC women as show leads that even Oh couldn't picture it for herself.

> "I think it's just as important what you say no to as what you say yes to."

Oh spent a decade playing supporting roles, "best friend" types—but in her own transgressive way. They weren't stereotypical roles for Asian actors. In fact, race played very little into the roles she was cast in—and she attributed that to working with women and BIPOC women who had visions beyond a black-and-white world. One of these women included Shonda

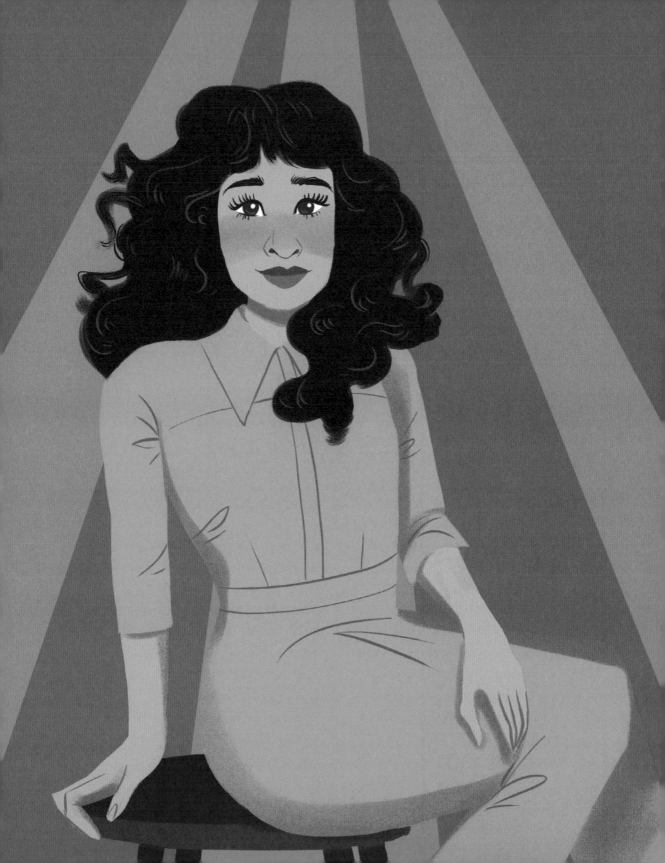

"I want to see myself as the Hero of any story."

— Sandra Oh

Rhimes, who created the television juggernaut *Grey's Anatomy*, which is known for being one of the first shows that created characters without assigning their race or ethnicity and instead chose the best actors for each role, resulting in a racially and ethnically diverse cast that more honestly reflected the real world. Oh landed the role of ambitious surgical intern Cristina Yang. It was a role that would earn her worldwide fame and five Emmy nominations for Best Supporting Actress in a Drama Series.

After ten seasons at *Grey's*, Oh stepped back and took a beat before returning to an even more iconic role—the lead of Phoebe Waller-Bridge's BBC television series *Killing Eve.* And while race is not a leading factor in that role, Oh still brings in nuances of her cultural experience to the show so that it feels like authentic representation. She asked the sound team for something as simple as leaving out the sound of shoes when her character is home, a nod to the fact that many Asian people do not wear shoes inside the house.

Her success as a lead actress allowed her to step into greater prominence as the first Asian Canadian female host of *Saturday Night Live*, first Asian host of the *Golden Globe Awards* in 2019, and the first woman of Asian descent to win multiple Golden Globes. Her visible success in a wildly white industry means so much to the Asian American community especially when fewer than 4 percent of US films feature Asian American and Pacific Islander (AAPI) actors in leading roles. With American and British films and television having a far-reaching and outsized impact on the global community, that means greater visibility for all non-white people. At fifty, she considers herself in the middle of her career, an attitude that will ensure she blazes a path unlike any other for many decades to come—and not just for Asian American women.

"It's an honor just to be Asian."

Sylvia Rivera

July 2, 1951–February 19, 2002

QUEER AND TRANSGENDER LIBERATION STAR

Born in New York to a Puerto Rican father and Venezuelan mother, Sylvia Rivera grew up through a turbulent childhood to become a legendary transgender and gay rights activist. As a teenage runaway, she found a community of fellow drag queens, which included Marsha P. Johnson, who became a close friend and mother figure. Together, they cofounded Street Transvestite Action Revolutionaries (STAR) to support queer and transgender youth. STAR was one of the first trans youth shelters and the first political organization focused on trans rights—working to push through the New York City Transgender Rights Bill and other antidiscrimination legislation.

When the police raid on Greenwich Village gay bar Stonewall Inn happened in the summer of 1969, Rivera was on the front lines of the uprising protesting the brutality. A courageous leader, Rivera often grabbed the mic to make herself seen and heard during the 1970s gay pride parades that largely ignored trans people.

"If it wasn't for the drag queen, there would be no gay liberation movement. We're the front-liners."

Her political engagement included joining Gay Activists Alliance and the Gay Liberation Front, groups that exercised citizens' civil rights

IN THAT ERA, THE WORD *TRANSGENDER* HADN'T COME INTO COMMON USE YET, SO RIVERA OFTEN REFERRED TO HERSELF AS A TRANSVESTITE, DRAG QUEEN, GAY GIRL, OR GAY BOY.

to petition for nondiscrimination ordinances. She was often the only one who spoke up and fought to include rights of trans minority and low-income queer youth who were frequently ignored in the groups' work, leading her to be called "The Rosa Parks of the modern transgender movement." Nurturing and compassionate, Rivera worked to support the visibility of intersectional queer people—putting the *T* in LGBTQIA+ rights in a time that most other civil rights fronts wanted to ignore them.

Although she passed in 2002, Rivera's legacy lives on in the Sylvia Rivera Law Project. The project works for the rights of all people to self-determine identity and expression regardless of race or income.

IN PURSUIT OF

Identity

Annie Dodge Wauneka

April 11, 1910–November 10, 1997

LEGENDARY MOTHER OF THE NAVAJO PEOPLE

Annie Dodge Wauneka, born into the Tse níjikíní clan of the Navajo Tribe, was a public health advocate, social justice crusader, and the second woman elected to the Navajo Tribal Council. Her father, Henry Chee Dodge, was an eloquent, well-respected leader in the council, and she often traveled with him to learn more about the concerns of their people. Believing that the future of the Navajo people lay in education, Wauneka spent twenty-nine years of her life in public service promoting progress so that her people could compete in the modern world while maintaining their cultural heritage.

> "I like to think of my life as a mirror which reflects life as it is."

GET TO KNOW ANNIE DODGE WAUNEKA

1. Wauneka's lifelong passion for public health education was inspired by her experiences during the 1918 Spanish flu epidemic. She survived a mild case of the flu and was able to help the school nurse when the boarding school she was attending was overwhelmed by the illness.

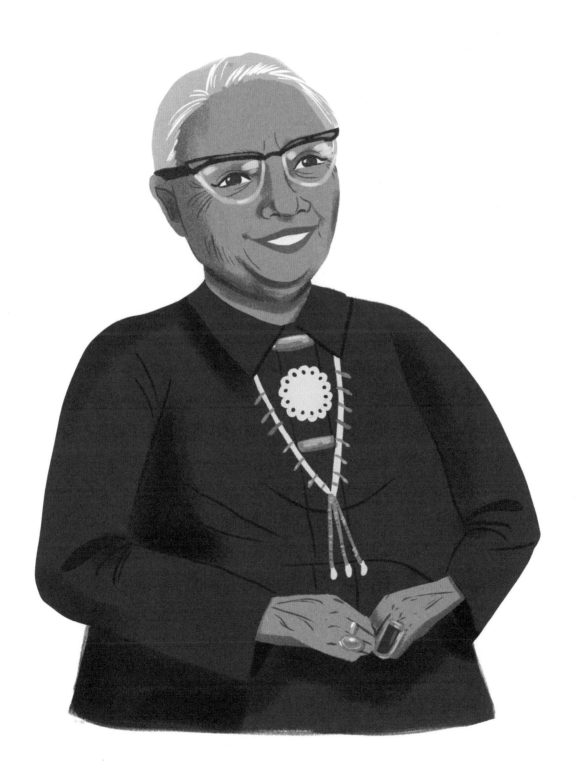

Wauneka stated, "I'll never forget that experience. It remains very clear in my memory, even today."

2. In May 1951, Wauneka became the second woman elected to the Navajo Tribal Council. She was known for her outspoken nature and clear opinions, advocating for the betterment of the Navajo reservation through employing more individuals and establishing reservation hospitals. She served for more than seven terms and improved the health conditions of tribes who lived across land covering more than 24,000 miles [38,000 kilometers].

3. After earning a degree in public health from the University of Arizona in Tucson, Wauneka gained prominence as a health advocate and educator on tuberculosis that was plaguing the Navajo Nation. She facilitated better communication between white doctors and traditional Navajo healers to provide a higher quality of care for Navajo patients. She would personally stay with patients in hospitals through medical tests, carefully translating and explaining health treatments, and drive long distances to keep them connected with family through taped messages.

4. Because there were no Navajo translations of more modern medical terms, Wauneka collaborated with a team of medical and Navajo practitioners to write an English-to-Navajo medical dictionary that made healthcare knowledge accessible.

5. She was especially skilled at identifying root causes of public health crises and worked to eradicate them through education. Her work on the prevention and spread of tuberculosis virtually eliminated the disease from the tribe. She also developed a polio vaccination program for Navajo children, flushed out waterborne illnesses through the creation of new water systems, and worked on many other public health system improvements.

6. The US surgeon general appointed Wauneka to the Advisory Committee on Indian Health in 1956, where she advocated for promoting education, preventing tuberculosis, and reducing the infant mortality rate. Because of her work, infant mortality in the Navajo Nation decreased by 25 percent in the 1960s.

7. In the 1960s, Wauneka hosted a weekly Sunday radio show where she discussed health information and covered topics ranging from alcoholism to infant care.

8. She was the first Indigenous person awarded the Presidential Medal of Freedom. She was also granted an honorary doctorate from the University of New Mexico in Albuquerque and inducted into the National Women's Hall of Fame. Most importantly, the Navajo Council honored her as a legendary mother of the Navajo people.

Dolores Huerta

April 10, 1930–

REVOLUTIONARY LABOR ACTIVIST

Raised in Stockton, California, by a single mother who was an entrepreneur and a compassionate supporter of migrant workers, Dolores Huerta is a Mexican American labor activist whose work has changed laws to improve the lives of many in the agricultural field. After a brief stint as an elementary school teacher, Huerta shifted careers to organize for working farm families' rights to fair wages and safe working conditions. At twenty-five, she joined Stockton's Community Service Organization (CSO) to support economic improvement for Latinx, Chicanx, and Mexican migrant farmworkers through lobbying and grassroots organizing. She saw how farmworkers were paid little to nothing, slept on dirt floors in shantytowns, suffered assaults from landowners, and had to bring their children with them while they traveled throughout the state seasonally for work—often taking kids out of school to work in the fields with them.

Through working at the CSO, she met fellow activist César Chávez. When the CSO didn't allow them to organize farmworkers, they broke off and formed the National Farm Workers Association (NFWA). Together they organized the monumental Delano grape strike. It was the first time striking and unionizing against the farm industry actually worked. The movement started in 1965, when more than two thousand Filipino farmworkers moved to strike against grape farms in San Joaquin Valley, California, due to poor work conditions. Their labor organizer, Larry Itliong, asked the NFWA to unite with them. The

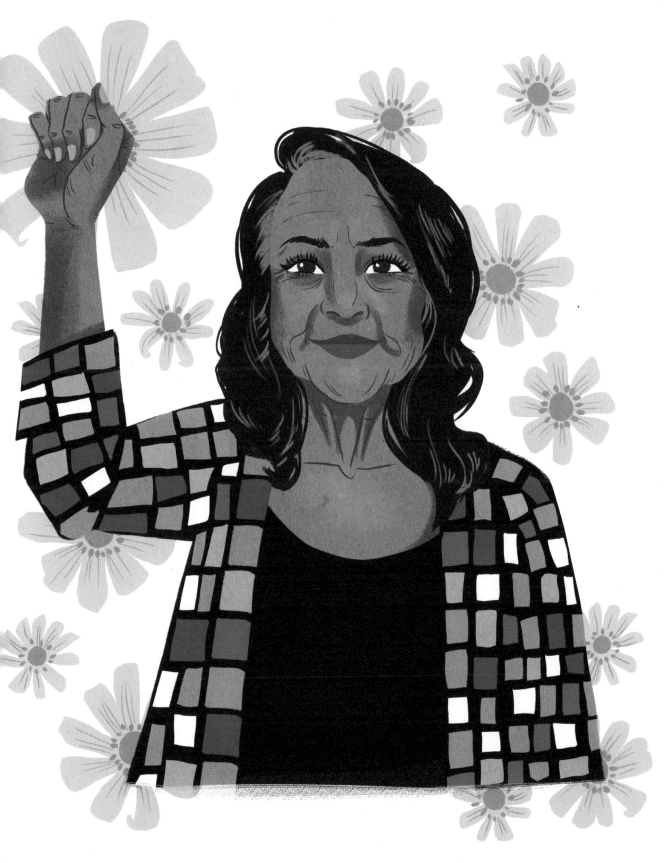

NFWA workers enthusiastically agreed, and the five-year strike began. Persevering through police brutality and growers' violence, the strikers called for a national boycott after three years of striking had changed nothing. Huerta and many fellow members of NFWA went door to door with pamphlets that convinced seventeen million Americans to stop eating grapes. That finally brought the industry to the collective bargaining table to give farmworkers a wage increase and basic rights. They drafted the first farm group contract in the United States. Next, Huerta went to Arizona to help organize against a law that criminalized boycotts—during this time, she coined the now legendary slogan "Sí, se puede!"

Much of her work led to meaningful passages of law, including the California Agricultural Labor Relations Act of 1975, which allowed farmworkers to create labor unions. She's been highly awarded for her work in securing civil rights for underprivileged groups (including being given the Presidential Medal of Freedom in 2012); she's also been arrested for civil disobedience and beaten by police at peaceful protests for the same work. A mother of eleven, Huerta continues her unconventional and incredible work well into her nineties in support of women's rights and electing more women and Latinx leaders into political office.

"We need a feminist to be at the table when decisions are being made so that the right decisions will be made."

Georgia Gilmore

February 5, 1920–March 7, 1990

CHEF SERVING UP RACIAL JUSTICE

On December 5, 1955, Georgia Gilmore officially joined the Montgomery Bus Boycott alongside five thousand other people. A vocal advocate for racial equality, Gilmore was fired from her cooking job at the National Lunch Company after she testified for Martin Luther King Jr. during a trial. A friend and champion, King encouraged her to start her own restaurant—and gave her the seed money to do it.

Meanwhile, she started the Club from Nowhere with a clandestine group of friends to help fund the Montgomery Improvement Association (MIA). Gilmore took the heat by naming herself as the only member of the organization, although the fundraising was a community effort. Women cooked and sold entire chicken dinners, cakes, and pies at boycott meetings, out of their homes, and in shops around town—raising as

much as $500 a week (equivalent to almost $5,000 in 2021) for the MIA. It would all go to fund auto costs for the carpools and taxis being organized by everyone boycotting the bus system.

Then, Gilmore opened her own restaurant in her home, which became a celebrated meeting place for the community and world leaders alike. It provided a safe space for organizers; King was a frequent patron. He'd have meetings with Lyndon B. Johnson and Robert F. Kennedy at her dining room table, over her heaping piles of fried chicken, stuffed pork chops, collard greens, candied yams, corn muffins, and sweet tea.

Even after the Supreme Court desegregated buses and ended the boycott in December 1956, Gilmore continued to be a vocal civil rights activist, and her home remained

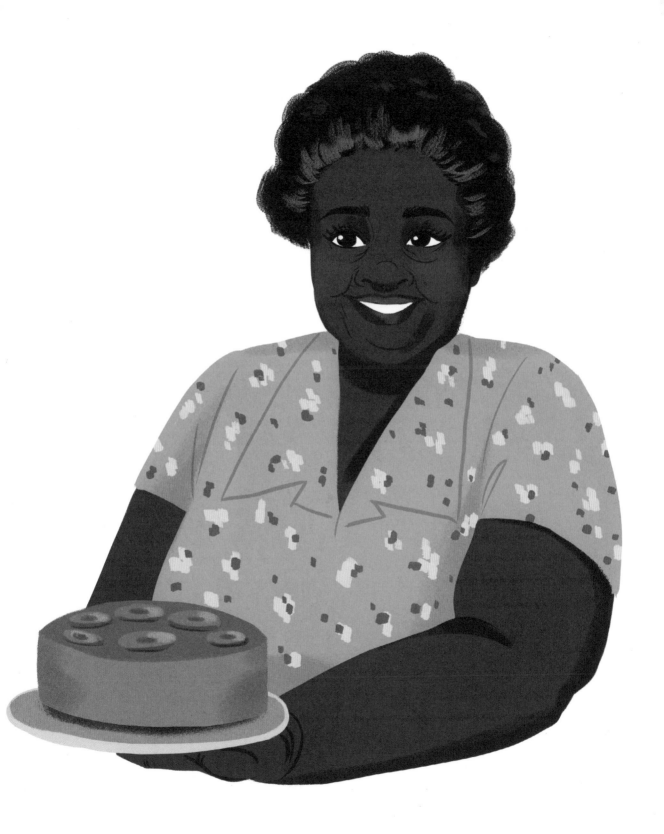

a safe haven for her community. Her food was her legacy—even up to her death. On the eve of the twenty-fifth anniversary of the Selma to Montgomery March, she passed away while preparing a meal for the marchers. The food she made was served at her service to a huge stream of supporters. Gilmore used her incredible skills and strength to do the most with what she had.

Jovita Idár

September 7, 1885–June 15, 1946

RAISED WOMEN UP THROUGH THE POWER OF EDUCATION

Mexican American civil rights activist, journalist, and suffragette Jovita Idár was born one of eight kids in Laredo, Texas. Her father, Nicasio Idár, was the editor and publisher of *La Crónica*—a newspaper that advocated for Mexican and Tejano rights, which brought her into activism at a young age.

With a pen as sharp as her tongue, Idár wrote her way into the hearts and homes of those in her community to pave a path for political organizing.

"Educate a woman, and you educate a family."

TIMELINE

1903

After getting her teaching certificate, Idár worked at a segregated school, where she was frustrated by the inadequacy of resources provided for the students despite Mexican Americans paying equal taxes.

1910

Sparked by her experience, she began working with her father and brother at *La Crónica*, writing under the pen names Astraea (the Greek goddess of justice) and Ave Negra (Spanish for "black bird").

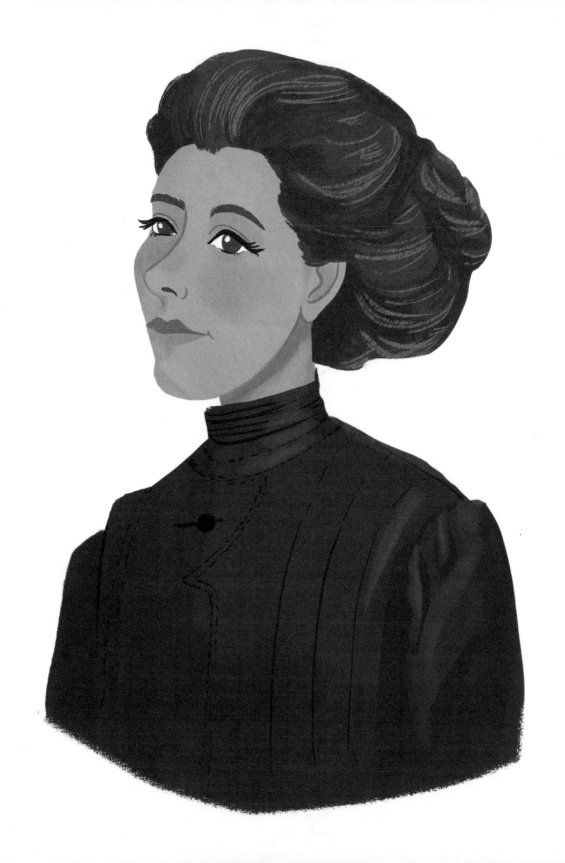

1911

Idár and her family organized the First Mexican Congress, bringing Mexican American activists together to fight racism, violence, and inequality—especially "Juan Crow" laws and lynchings targeting Mexican American men. She also founded La Liga Femenil Mexicanista (the League of Mexican Women) to offer free education to Mexican children, and to provide food and clothes to those in need, and unity on labor organizing and women's issues.

1913

When the Mexican Revolution came to the Rio Grande, Idár crossed over to the Mexican side of the border to volunteer as a nurse with La Cruz Blanca, the White Cross in Mexico.

1914

Idár wrote an editorial in *El Progreso* criticizing President Woodrow Wilson for sending US troops to the border. This offended the Texas Rangers, who attempted to close the newspaper offices, but Idár stood strong at the entrance and they could not pass. After retreating, they came back the next morning when no one was around and destroyed the printing presses.

When her father passed this same year, Idár took over editing *La Crónica* and continued to expose the violent and bigoted treatment of Mexican Americans and immigrants.

1921

She and her husband, Bartolo Juárez, moved to San Antonio, where they set up the local Democratic Club. Idár also founded a free kindergarten, worked as a Spanish-language interpreter at a hospital, and coedited the *El Heraldo Christiano* newspaper.

Kathleen "Kay" Livingstone

October 13, 1919–July 25, 1975

CANADIAN BROADCASTER WHO SPOTLIGHTED BLACK TRADITIONS

Ontario-born Kay Livingstone was a driving force behind the formation of Canada's first National Congress of Black Women. Educated in music at The Royal Conservatory of Music and the Ottawa College of Music, Livingstone hosted radio shows and acted in theater and film—becoming one of Canada's leading Black performers. With *The Kay Livingstone Show,* she made history as the first Black woman to host her own radio show; it celebrated Black cultural traditions around the world.

When she and her husband moved their family of seven to Toronto, Livingstone joined a Black middle-class women's social club called the Dilettantes who met for tea and threw garden parties. She soon became its first president and transformed it into the Canadian Negro Women's Association (CANEWA), a community organization that hosted festivals like the Calypso Carnival—the first to celebrate Black and Caribbean culture—and funded scholarships for young Black students. Through CANEWA, Livingstone organized the first National Congress of Black Women conference in 1973, connecting more than two hundred women across Canada in a convention of workshops on education, single parenting, and senior citizens. This first conference led

CANEWA ADOPTED THE RESILIENT CACTUS, WITH ITS RED FLOWER, AS THEIR SYMBOL TO REPRESENT THE STRENGTH OF BLACK WOMEN.

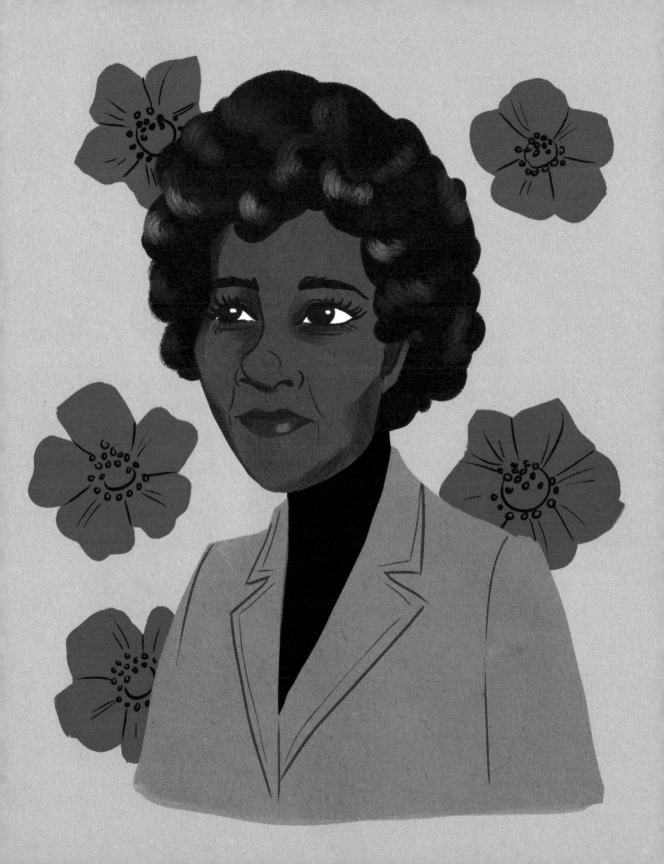

ONWARD AND UPWARD UPWARD LIFTING AS WE CLIMB

— KAY LIVINGSTONE

to more being held across Canada, and ultimately to the creation of a brand-new official group: the Congress of Black Women of Canada (CBWC). The CBWC formed a foundation that facilitated programs to foster "advancement, recognition, history, and education of black women and their families." Throughout her life, Livingstone played major roles at places like the United Nations Association, Heritage Ontario, and the YWCA, working tirelessly to create a more equitable and tolerant society. She coined the term "visible minority" while working on the International Women's Year Committee, and in 1975 worked with the Canadian Privy Council to organize a national conference of visible minority women. Today, the Kay Livingstone Award is given annually to a Black woman in Canada who works to improve the lives of visible minority women and their families.

Madonna Thunder Hawk

1940–

INDIGENOUS RIGHTS ACTIVIST AND ORIGINAL GANGSTA GRANNY

Born on the Yankton Sioux Reservation in South Dakota, Madonna Thunder Hawk is a member of the Feather Necklace tiospaye (extended family) of the Cheyenne River Sioux Tribe. Her oldest takoja (grandson) nicknamed her the "original gangsta granny" due to her life-long fight for Indigenous rights.

"We have the right to be who we are."

GET TO KNOW MADONNA THUNDER HAWK

1. In her twenties, she joined the Red Power movement—a movement for Indigenous self-determination led by Indigenous youth. Thunder Hawk participated in multiple land and civil rights protests, including the 1969–1971 Occupation of Alcatraz; the 1970 and 1971 occupations of Mount Rushmore; the Trail of Broken Treaties in 1972, which ended with an occupation of the Bureau of Indian Affairs in Washington, DC; the 1973 occupation of Wounded Knee; and the 2016 Dakota Access Pipeline protests.

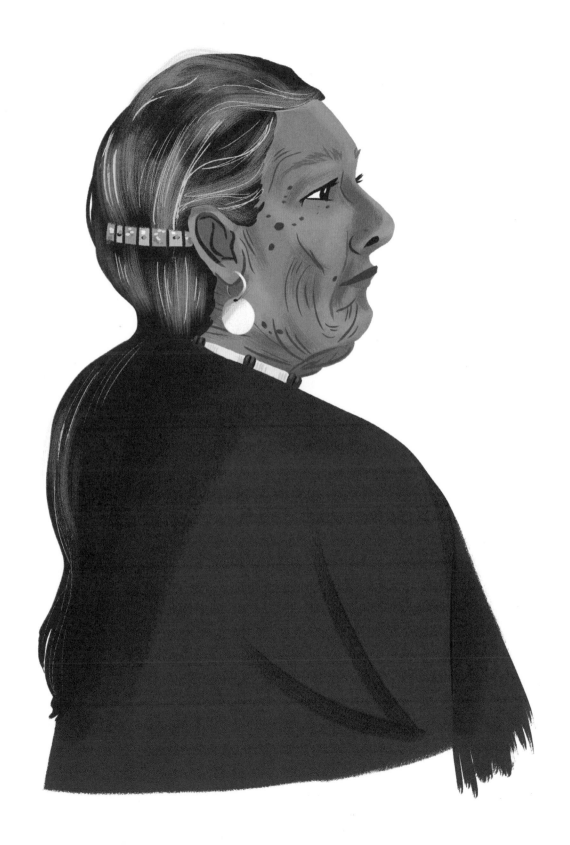

2. Thunder Hawk became a leader in the American Indian Movement (AIM) in the late 1960s, which works for Native sovereignty and self-determination.

3. She cofounded Women of All Red Nations, a group that focuses on Indigenous women's rights, including sterilization abuse, political imprisonment, and land threats; and the Black Hills Alliance, which blocked uranium mining from sacred Lakota land.

4. She founded the Wasagiya Najin, a grandmothers' group that oversees child welfare matters in the community by rebuilding kinship networks and stopping the removal of children.

5. Thunder Hawk is the principal organizer and tribal liaison for the Lakota People's Law Project, which pushes for federal reform of the Indian Child Welfare Act to enable more Lakotan youth to stay with their families instead of being shipped off to boarding schools far from their ancestral homelands.

6. She founded the We Will Remember Survival School for Native youths without parental figures or who were pushed out of boarding school educational systems, giving them a safe place to sleep, eat, and self-determine their education without cultural genocide.

7. After finding kinship with the native Irish on a speaking tour, Thunder Hawk went on to speak around the world about Indigenous rights. She served as a United Nations delegate during the Human Rights Commission in Geneva; the UN Decade of Women Conference in Mexico City; and World Conference against Racism in Durban, South Africa.

8. Thunder Hawk founded the Warrior Women Project with her daughter, Marcella Gilbert. The project creates a forum for Indigenous women to collaborate on scholarship, media, and activism to become keepers of their own cultures.

"For the
INDIGENOUS
AROUND THE WORLD
REGARDLESS OF COLOR,
IT IS a STRUGGLE
FOR THE LAND AND
WHO YOU ARE."
—Madonna Thunder Hawk

Whina Cooper

December 9, 1895–March 26, 1994

MĀORI LAND RIGHTS ACTIVIST AND MOTHER OF THE NATION

In 1975, the diminutive yet powerful seventy-nine-year-old Whina Cooper led a march across 685 miles [1,100 kilometers] in New Zealand to secure land rights for the Māori people. The march started with fifty people on September 14th and swelled to five thousand over the course of a month as they marched across towns and cities leading to the steps of Parliament. On October 13, they arrived in Wellington, where Cooper presented a "Memorial of Rights" and a petition signed by sixty thousand people to Prime Minister Bill Rowling and National Party leader Robert Muldoon. This protest raised the profile of Māori as individuals and contributed to the establishment of the Treaty of Waitangi Act 1975, creating a Waitangi Tribunal that investigated governmental injustices toward the Indigenous people of New Zealand. The tribunal's investigation, along with many more protests leading up to it, eventually led to a government apology, reparations, and return of Māori land. Cooper's leadership earned her the title Te Whaea o te Motu (Mother of the Nation).

"Not one more acre of Māori Land."

A daughter of the Ngāti Manawa iwi (tribe), Cooper received an education few had access to, and she used it throughout her life to give back to the community—first through teaching, and then through activism. Her first involvement in land rights preservation was when she was eighteen. There was a dispute over the Whakarapa mudflats where a leasing farmer, Bob Holland, wanted to drain the estuaries

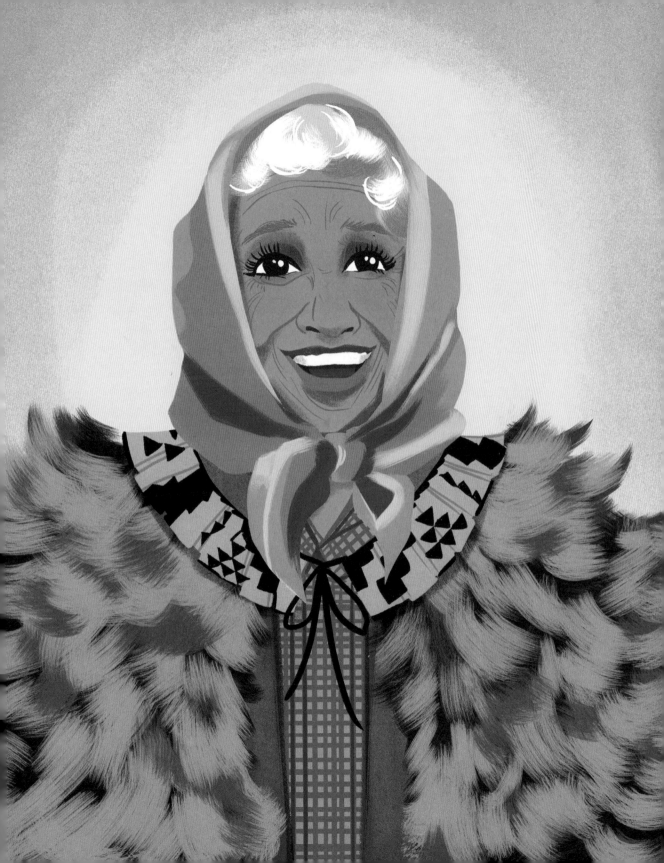

to create cattle farmland. However, the Māori people used the naturally flooding swamp to gather seafood during the wet season and race horses when it dried out. She led a group of young adults to fill in the land as fast as the Hollands could dig it while her father challenged the lease through Parliament—buying him enough time to have the lease withdrawn legally. Her extraordinarily strong will also led her to lead a life on her terms—refusing an arranged marriage, she ran away from home and chose to marry whom she wanted, a controversial choice in the community-focused culture. Despite that, Cooper quickly became a legendary leader. She opened successful businesses selling imports from the United Kingdom and exporting New Zealand natural resources that she farmed, and served in leading roles in church and community activities—including being appointed the president of the Māori Women's Welfare League. Through a lifetime of land rights activism and service to Māori culture, Cooper was given the Imperial and New Zealand Royal Honours, including the title of Dame in 1981.

Wilma Mankiller

November 18, 1945–April 6, 2010

FIRST FEMALE PRINCIPAL CHIEF OF THE CHEROKEE NATION

Born in Tahlequah, Oklahoma, Wilma Mankiller was the sixth of Charley Mankiller and Clara Irene Sitton's eleven children. Her surname, Mankiller, translates to Asgaya-dihi in Cherokee and refers to a traditional military rank. At twelve years old, she and her family were forced to relocate from her grandfather's allotment of land called Mankiller Flats in Adair County, Oklahoma, to San Francisco as part of a US government initiative to assimilate Indigenous people. She called it her own "trail of tears."

In her early twenties, Mankiller became involved with the Occupation of Alcatraz to raise awareness about Indigenous land rights—which sparked a life path devoted to civil rights activism. After a divorce and her father's passing, Mankiller and the rest of her immediate family moved back to reclaim Mankiller Flats in 1977. There, Mankiller founded the Cherokee Nation's Community Development Department in 1981—her first project was to fundraise and construct a 16-mile [26-kilometer] waterline for the small Cherokee community of Bell, Oklahoma.

In 1983, she won an election for deputy principal Cherokee chief, and two years later became principal chief—the first woman to ever serve as chief of an Indigenous tribe. During her ten-year tenure, and against rampant sexism and little support, she vastly improved the quality of life for the Cherokee Nation while maintaining their traditions. She lowered the unemployment rate, increased educational opportunities, and opened community health centers while raising the budget to $150 million a

"THE SECRET OF OUR SUCCESS IS THAT WE never, NEVER give up." — WILMA MANKILLER

year through the opening of many new factories and businesses.

Even after she left office due to ill health in 1995, she remained actively involved in tribal affairs and guest lectured at Dartmouth College. In 1998, she was awarded the Presidential Medal of Freedom by President Bill Clinton for her work in improving the lives of Indigenous people. Mankiller passed in 2010 from pancreatic cancer, and her funeral was attended by 1,200 people, including close personal friend Gloria Steinem. Steinem stated about her friend: "Ancient traditions call for setting signal fires to light the way home for a great one; fires were lit in twenty-three countries after Mankiller's death. The millions she touched will continue her work, but I will miss her every day of my life."

Zitkála-Šá

February 22, 1876–January 26, 1938

FIRST INDIGENOUS PERSON TO WRITE AN OPERA

EARLY LIFE

Born to a Yankton Sioux mother and white father, Zitkála-Šá spent her youth on the Yankton reservation until she was eight years old. She attended White's Indiana Manual Labor Institute, a boarding school, which contributed to an incredibly formative experience with assimilation and the erasure of Indigenous culture. Despite her struggles with the school environment, she excelled in reading, writing, and playing the violin. She earned a scholarship to Earlham College and studied at the New England Conservatory of Music before briefly becoming a teacher herself.

WRITING LIKE THE WIND

She started publishing essays and short stories in *Atlantic Monthly* and *Harper's Monthly* about her struggles and life as an Indigenous woman stuck between two cultures and detailing the pain of the assimilation process—when Indigenous children were sent to boarding schools and stripped of their cultural identities. With much of her focus on sharing and preserving Indigenous culture and values, she also published three books: *Old Indian Legends*, *American Indian Stories*, and *Oklahoma's Poor Rich Indians*. Her work was popularly acclaimed across the country, even gaining readers like Helen Keller, who wrote her a personal fan letter.

THE SUN DANCE OPERA

In 1913, combining her love of music and writing, Zitkála-Šá became the first Indigenous person to write an opera. She worked with

William Hanson, a music professor at Brigham Young University. *The Sun Dance Opera* was based on her essays and was a tribute to how most Indigenous customs and stories are passed on through oral history. It premiered at the Orpheus Hall in Vernal, Utah, to much acclaim.

POLITICAL LEGACY

In 1916, she and her husband, Captain Raymond Bonnin, who was also a mixed-race Yankton Sioux, moved to Washington, DC. She began publicly speaking about the importance of passing civil rights laws that guaranteed the preservation of Indigenous tribal identities. Together they also founded the National Council of American Indians, connecting tribes across the country for a unified front to protect themselves when working with the US government. She would serve as president until her death. Through her lobbying work, the 1924 Indian Citizenship Act and 1934 Indian Reorganization Act were passed. Both acts granted Indigenous people more independence and civil rights.

IN PURSUIT OF

Knowledge

Anandibai Joshee

March 31, 1865–February 26, 1887

FIRST HINDU FEMALE DOCTOR

Anandibai Joshee was the first woman from India to receive a medical degree in the United States; she returned to her home country to become the first female Hindu doctor. One of the earliest pioneers in recognizing that healthcare is inherently biased by race and religion, Joshee sought to merge Ayurvedic and Western medicine in order to better treat Hindu women who were dying in disproportionately high numbers due to inadequate care.

GET TO KNOW ANANDIBAI JOSHEE

1. She had a child at age fourteen (after being married at nine, a socially acceptable practice at the time), but lost her son ten days later due to poor medical care—this was the event that sparked her interest in medicine.

2. Her husband, Gopalroa, encouraged Joshee to study medicine. He sent a letter to an American missionary asking for support to send himself and Joshee to the United States so she could study there. The letter was published in the *Missionary Review,* which helped Joshee gain American patrons.

3. Since most of her supporters were Christian missionaries who wanted her to convert, she gave a public speech at Serampore College Hall announcing her decision to study medicine abroad in order to better serve Hindu women. She emphasized the need for Hindu female

doctors and pledged not to convert—which earned her the support of the Hindu community who rallied together financially to help send her to the United States.

4. In 1886, Joshee became the first Indian woman to earn her medical degree from Women's Medical College of Pennsylvania. She graduated alongside Kei Okami (of Japan) and Tabat Islambooly (of Syria), who were the first women of their respective countries to receive Western medical degrees.

5. In recognition of Joshee's graduation from medical college, Queen Victoria sent her a personal letter of congratulations on her accomplishments.

6. Upon her return to India after graduation, Joshee was appointed the head physician of the female ward at Albert Edward Hospital in Kolhapur.

7. While her achievements would go on to inspire generations to come, her time to practice was short-lived as a bout of tuberculosis ended her life at twenty-one, just one year after her graduation. Today in India, women now outnumber men in medical school.

PER MAHARASHTRIAN CUSTOM, HER HUSBAND
GAVE HER A NEW NAME UPON MARRIAGE:
"ANANDIBAI" MEANING "JOY OF MY HEART."

Charlotta Bass

February 14, 1874–April 12, 1969

FIRST BLACK WOMAN TO OWN AND OPERATE A US NEWSPAPER

EAST COAST ROOTS

Charlotta Bass studied at Pembroke College, a women's college that is now part of Brown University. She got her start in the publishing business selling ads and subscriptions for the Black-owned newspaper *Providence Watchman* before moving to California.

CHARLOTTA GOES WEST

A lifelong sufferer of arthritis and asthma, Bass headed for the milder climates of Los Angeles, where she took a job at *The Eagle* in 1910. Two years later, when founder and owner John Neimore fell ill, he asked Bass to make a bid for the newspaper because he wanted her to take over. She won the paper in an auction with fifty dollars she borrowed from a store owner— and with that, she became the first-known Black female owner of a newspaper in the United States.

THE CALIFORNIA EAGLE SOARS

During Bass's reign, she brought on veteran journalist Joseph Bass as editor while she remained managing editor. Joseph and Charlotta married in 1914, and together they built the largest Black newspaper in circulation on the West Coast. It went from a four-page tabloid to a twenty-page weekly newspaper. By the 1930s, they were distributing up to sixty thousand copies. Bass made sure to highlight the positive achievements of the Black community at a time when mainstream media only focused on Black people when it came to reporting crimes.

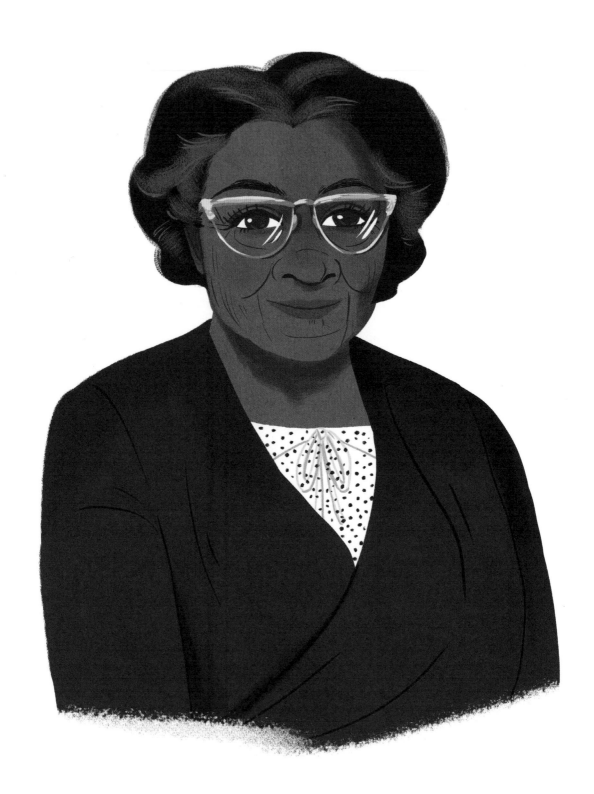

DON'T MESS WITH BASS

Through the *California Eagle*, Bass was an outspoken critic of racial injustice, housing and employment discrimination, police violence, and the growing crimes of the KKK in Southern California. After winning a libel lawsuit the KKK filed against her, she was confronted in her office one night by eight members in white sheets. She pulled out a pistol she kept in her top drawer, and they retreated. She recalled that evening: "I had never handled a gun before and wasn't quite sure which end to point at the intruders, but they evidently thought I knew how to shoot and all eight made a hasty retreat." In the 1930s, she brought the "Don't Spend Where You Can't Work" boycott to LA and opened doors for Black people at major employers like the Los Angeles Railway. She also helped form the Home Owners Protective Association and fought housing discrimination.

NEVERTHELESS, SHE PERSISTED

All of Bass's contributions in bringing racial equality to the forefront of the media made her a target of the US government. The FBI labeled her a communist because of her work, including her service as a member of the Peace Committee of the World Congress in Paris and Prague. The United States Postal Service unsuccessfully tried to revoke her permit for her newspaper, and the State Department confiscated her passport—but nevertheless, she persisted.

"WIN OR LOSE, WE WIN BY RAISING THE ISSUES"

Bass entered the political arena in the 1940s when she ran for LA City Council. She helped form the Independent Progressive Party of California in 1947 after she realized the main two parties didn't serve the interests of people of color,

women, or immigrants. In 1952, Bass became the first Black woman to run for the office of vice president alongside Vincent Hallinan on the Progressive Party ticket. Their slogan for the long-shot campaign was "Win or Lose, We Win by Raising the Issues." Their issues were opposing militarism and war and pushing for social justice and economic equality. Though their bid ended with a loss to Dwight D. Eisenhower, their issues remain just as pressing today as they were in the 1950s. Bass charted a path for so many others, including Kamala Harris, showing Black women as viable leaders in our communities.

WIN OR LOSE

WE WIN BY

Raising the Issues

Chien-Shiung Wu

May 31, 1912–February 16, 1997

THE FIRST LADY OF PHYSICS

Born and raised in Jiangsu, China, Chien-Shiung Wu immigrated solo to the United States in her early twenties to further her studies—and in doing so, changed the foundation of our understanding of physics. Her 1956 experiment on nuclear particles (particularly the conservation of parity now named the Wu Experiment) became a part of the standard model of particle physics—and garnered her male counterparts, theoretical physicists Tsung-Dao Lee and Chen Ning Yang, Nobel Prizes. But she was notoriously excluded from the honor, theorized to be because of her gender and race. Though she often gets noted for *not* winning a Nobel Prize, Wu *did* go on to win many accolades and titles throughout her expansive career—including the National Medal of Science, the Comstock Prize in Physics, and the Wolf Prize in Physics. She was even honored on a US postage stamp in 2021.

"I wonder whether the tiny atoms and nuclei, or the mathematical symbols, or the DNA molecules have any preference for either masculine or feminine treatment."

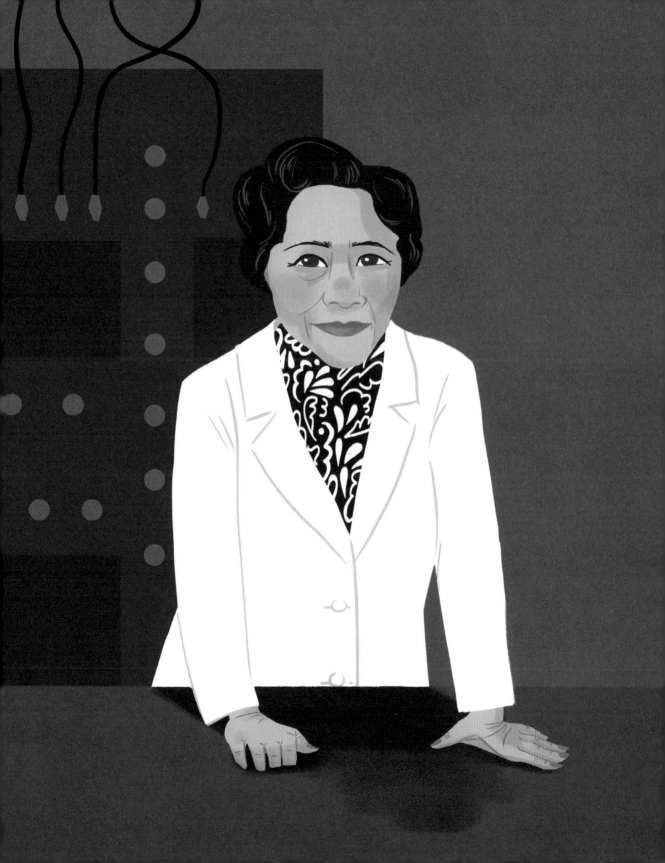

GET TO KNOW CHIEN-SHIUNG WU

1. Wu attended Mingde Women's Vocational Continuing School, which was unusual at the time since educating girls was not the norm. She loved her time there so much that her wishes were to be buried there when she passed, which was fulfilled in 1997.

2. She set sail to the United States at the age of twenty-four to get her PhD at the University of California, Berkeley. Her parents never saw her again due to World War II and the Chinese Civil War years that followed.

3. Wu became a professor and taught at Smith College, Princeton University, and Columbia University. She was the first woman hired in the physics department at Princeton.

4. In 1944, Wu joined the Manhattan Project at Columbia University. Her research there improved Geiger counters for the detection of radiation and enrichment of uranium. She went on to lead research that touched everything from beta decay to sickle cell anemia.

5. When she was referred to as Professor Yuan (her husband's last name), she would correct people that she was Professor Wu—which, while uncommon to use one's maiden name at the time in the United States, was normal for women in Chinese culture.

6. In 1975, Wu became the first female president of the American Physical Society, the leading nonprofit membership organization for professionals in physics and related disciplines, both in the United States and internationally.

7. Later in life, she became an outspoken advocate for women's right to work. She stated: "There is only one thing worse than coming home from the lab to a sink full of dirty dishes, and that is not going to the lab at all!"

Ida B. Wells

July 16, 1862–March 25, 1931

GROUNDBREAKING JOURNALIST FOR RACIAL JUSTICE

EARLY EDUCATION TO EDUCATOR

Ida Bell Wells was born an enslaved person in Mississippi but was freed when the Emancipation Proclamation went into effect in 1863. After her parents' untimely deaths from a yellow fever epidemic, Wells took a job as a teacher at sixteen to keep her younger siblings together. Two years later, Wells and two of her younger sisters moved in with an aunt in Memphis, Tennessee.

THE MAKING OF AN ACTIVIST

In Tennessee, Wells continued to teach and attended school at Fisk University in Nashville. After she was dragged off a train car for refusing to give up her seat, she took the railroad company to court. Her negative experience with losing the case sparked her lifelong devotion to civil rights activism. She began writing for weekly papers *Evening Star* and *The Living Way* and became editor and co-owner of the Black-founded newspaper *Free Speech and Headlight*. Her focus was calling out racist Jim Crow policies. Her activism got her fired from her teaching post, but that only freed her up to focus full-time on her journalism.

THE ANTI-LYNCHING CAMPAIGN BEGINS

After losing her friend Thomas H. Moss Sr. to a lynch mob in March 1892, Wells began her investigation on exposing the lynchings happening across the South. The southern white population was incensed by her articles outlining the many dismissals of lynching cases of Black men who had been

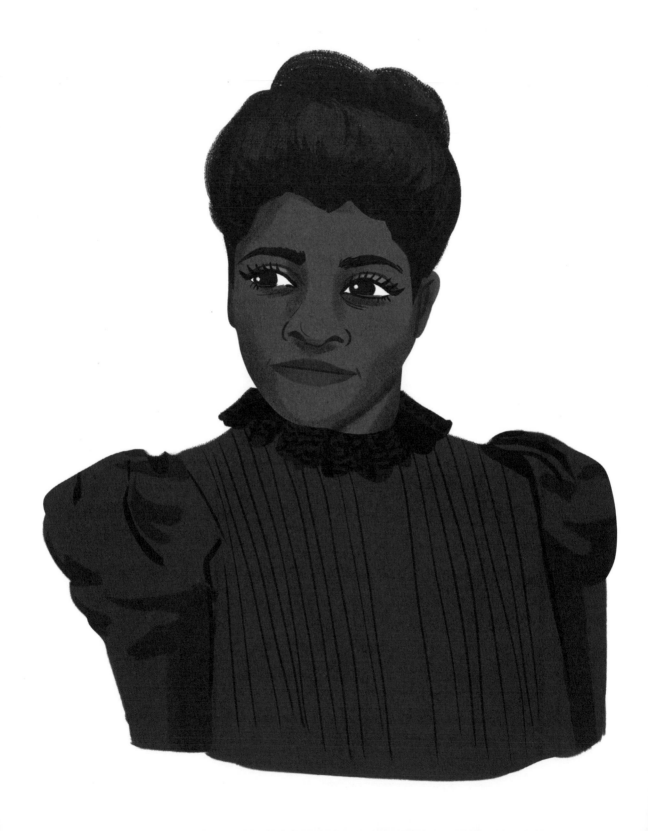

accused of raping white women. She wrote the accusations were "an old threadbare lie." In May, a white mob destroyed the *Free Speech* offices and all existing copies of the paper. Fortunately, Wells was in New York—where she would stay.

"THE PRINCESS OF THE PRESS"

Wells published two influential pamphlets on her research on lynchings titled *Southern Horrors: Lynch Laws in All Its Phases* (1892) and *The Red Record* (1895). Both detailed specific incidences of lynching—reported by white newspapers—and the ways that white Americans continued to disenfranchise Black Americans through poll taxes, literacy tests, segregation laws, and, when those didn't work, violence. She wrote that during Reconstruction, white Americans were most scared of Black people rising up through leadership positions and voting. So they continued to chip away at the rights of Black citizens to make it almost impossible. It's a legacy that continues today. As of this writing in 2022, lynching is still not a federal crime in the United States.

BECOMING A FIRST

These pamphlets and her accompanying lecture circuit educated northerners and audiences abroad about the horrors of lynching and racial discrimination. She gained global support for her anti-lynching cause. While abroad in Britain, the editor of the Chicago-based *Daily Inter Ocean*, the only white paper that denounced lynching, hired Wells as a correspondent. She became the first Black American woman to be a paid correspondent for a mainstream newspaper.

FAMILY MATTERS

In June 1895, Wells married famed attorney and civil rights activist Ferdinand L. Barnett, and they would go on to raise six children—two from his previous marriage and four of their own. Because of her kids, she established Chicago's first kindergarten for Black children.

COMMUNITY ORGANIZER EXTRAORDINAIRE

After settling in Chicago, Wells expanded her community involvement to focus not only on civil rights but also on women's rights and suffrage. She was a member of the National Equal Rights League, and cofounded the Negro Fellowship League, the Women's Era Club, the National Association of Colored Women's Clubs, the Alpha Suffrage Club, the National Afro-American Council, and the NAACP.

BAD GIRL FOR LIFE

Because of her incredibly forward-thinking efforts, she was a controversial figure during her time—people thought she was pushing for too much too soon. When the National American Woman Suffrage Association organized a suffrage march on Washington, DC, the day of Woodrow Wilson's inauguration, they asked Wells to walk in the back with the "colored" delegation. Instead, she decided to wait with the spectators and jumped into the parade when her fellow members of the Illinois delegation, white suffragettes Belle Squire and Virginia Brooks, came by. The linking of their arms showed the world that women's rights was an intersectional issue.

"The way to right WRONGS is to turn the LIGHT of TRUTH upon them."

— IDA B. WELLS

Marie Van Brittan Brown

October 30, 1922–February 2, 1999

INVENTOR OF THE HOME SECURITY SYSTEM

Marie Van Brittan Brown was a nurse and an innovator born in Jamaica, Queens, New York, where she lived her whole life. In 1966, she invented a video home security system along with her husband, Albert Brown, an electronics technician. The invention was truly a mother of necessity—as a nurse, Brown worked irregular hours and needed more home security when she was home alone, especially with the increasing crime rate and slow police response in Queens. Brown hated that she couldn't see who was at the door without opening it, so she created three peepholes in the door—for tall and average-height adults, plus one at children's height. There was a movable camera at those peepholes that wirelessly transmitted to a television in the house. This was the precursor to closed-circuit surveillance programs that are widely utilized now. She also invented a button that could sound an alarm and contact authorities immediately and a two-way microphone used to communicate without opening the door. She received an award from the National Scientists Committee for her invention. In 1969, she received the US patent for her security system, titled "Home Security System Utilizing Television Surveillance." Her signature invention still impacts modern home security systems: Thirteen inventions since have referenced the couple's patent, even as recently as 2013.

Pura Belpré

February 2, 1899–July 1, 1982

LIBRARIAN OF THE PEOPLE

In 1921, a fateful visit to her sister's wedding in New York City changed the course of Pura Belpré's life—and the future of libraries and the Latinx community. Born and raised in Cidra, Puerto Rico, Belpré was studying to become a teacher during her visit when she was recruited by the New York Public Library (NYPL) as their first Puerto Rican librarian. The NYPL had created an initiative to expand their staff to include more women of color. Soon, Belpré was placed in Harlem, where a large Spanish-speaking population was growing. She supported the community by creating bilingual storytelling hours, adding Spanish-language books to the library's collection, and including the celebration of traditional Latin holidays like Three Kings Day in the library's programming. Frustrated with the lack of Spanish-language books for children, Belpré took it upon herself to write down the Puerto Rican folklore she grew up with—two of which ended up becoming the books *Pérez y Martina* and *Juan Bobo and the Queen's Necklace*. Many of her written folktales were published, which created greater representation for Puerto Rican culture in collections and helped many children feel more at home. She'd write scripts and act out the tales herself during story hours with puppets she made, creating a traveling puppet theater that went to wherever children and families gathered. Belpré performed in English *and* Spanish, which hadn't been done before. Her community outreach and focus on early childhood literacy created a bridge of access between the Latinx community and the public library—allowing an overlooked population greater

access to resources. Belpré's work filled a gap on the shelves, helping embroider Puerto Rican culture into the fabric of the country. She was honored with the New York Mayor's Award for Arts and Culture in 1982. After her passing that same year, the American Library Association established the Pura Belpré Award for Latinx writers and illustrators that best portray cultural experience in a work of children's literature. Her puppets are still a part of NYPL's collection.

"TO APPRECIATE THE PRESENT, ONE MUST HAVE A Knowledge OF THE PAST... TO KNOW WHERE WE GO WE MUST KNOW FROM WHERE WE CAME."

– PURA BELPRÉ

Susan La Flesche Picotte

June 17, 1865–September 18, 1915

FIRST INDIGENOUS DOCTOR

A lone lantern glows in the window of a house. The light is always on, through rain or snow and at every hour of the day. The house belongs to Dr. Susan La Flesche Picotte, the only doctor serving the Omaha Nation, which spanned more than 400 miles [640 kilometers] and included more than twelve hundred patients. And she served every one of them.

When eight-year-old La Flesche Picotte witnessed an elderly woman die after the only doctor in the region neglected to come see her, the young girl was emboldened to study medicine even though no Indigenous person had done so before, much less a woman. Indigenous people weren't even full US citizens at the time. But with the encouragement of her parents and the financial support of the Women's National Indian Association, La Flesche Picotte enrolled at the Woman's Medical College of Pennsylvania, the first of its kind. During this era, even the most privileged women were discriminated against for studying medicine. La Flesche Picotte did it anyway and graduated valedictorian of her class in 1889.

She returned to the Omaha reservation after securing a physician position with the Office of Indian Affairs. By integrating traditions of medicine men with her Western education, La Flesche Picotte was able to earn the trust of the community. Soon she was

the only doctor there and worked twenty-hour days making house calls by horse to treat everything from tuberculosis to influenza. After her children were born, she often brought her two small boys with her on house calls, especially after their father died of tuberculosis exacerbated by alcoholism. Her husband's death brought on a passion for public health reform; she became a vocal advocate for temperance as alcoholism seized the reservation, as well as for proper hygiene practices to stem the spread of disease. She long dreamed of opening the first modern hospital on reservation land that would serve Indigenous and white people alike, and worked hard to raise $8,000 in private funds to do so. Her dream was realized when the Dr. Susan La Flesche Picotte Memorial Hospital opened in 1913 in Walthill, Nebraska, on the Omaha Indian Reservation, just two years before she passed away. It was declared a historical landmark in 1993.

I shall always fight GOOD & HARD even if I have to fight alone.

—SUSAN LA FLESCHE PICOTTE

References

ALEXANDRIA OCASIO-CORTEZ

Alter, Charlotte. "'Change Is Closer Than We Think.' Inside Rep. Alexandria Ocasio-Cortez's Unlikely Rise." *Time,* March 21, 2019. time.com/longform/alexandria-ocasio-cortez-profile.

Freedlander, David. "Alexandria Ocasio-Cortez Has Already Changed D.C. It Hasn't Changed Her Much." *New York,* January 6, 2020. Intelligencer. nymag.com/intelligencer/2020/01/aoc-first-year-in-washington.html.

Lears, Rachel, dir. *Knock Down the House.* New York: Jubilee Films, 2019.

Maxouris, Christina, and Saeed Ahmed. "Alexandria Ocasio-Cortez's Campaign Shoes to Join Museum Exhibition." CNN.com, November 23, 2018. cnn.com/style/article/alexandria-ocasio-cortez-shoes-style-trnd/index.html.

Read, Bridget. "28-Year-Old Alexandria Ocasio-Cortez Might Just Be the Future of the Democratic Party." *Vogue,* June 25, 2018. vogue.com/article/alexandria-ocasio-cortez-interview-primary-election.

Schwartz, Matthew S. "Ocasio-Cortez Fundraising Drive for Texas Relief Raises $4 Million." NPR, February 21, 2021. npr.org/sections.live-updates-winter-storms-2021/2021/02/20/969809679/

ANANDIBAI JOSHEE

India Today Web Desk. "Who Is Anandi Gopal Joshi to Whom Google Dedicated a Doodle?" *India Today,* March 31, 2018. indiatoday.in/education-today/gk-current-affairs/story/who-is-anandi-gopal-joshi-to-whom-google-dedicates-a-doodle-1201625-2018-03-31.

McNeill, Leila. "This 19th Century 'Lady Doctor' Helped Usher Indian Women Into Medicine." *Smithsonian Magazine,* August 24, 2017. smithsonianmag.com/science-nature/19th-century-lady-doctor-ushered-indian-women-medicine-180964613.

Nagarajan, Rema. "More Women Study Medicine, but Few Practise." *The Times of India,* Updated January 11, 2016. timesofindia.indiatimes.com/india/more-women-study-medicine-but-few-practise/articleshow/50525799.cms.

Rao, Mallika. "Meet the Three Female Medical Students Who Destroyed Gender Norms a Century Ago." *The Huffington Post,* December 7, 2017. huffpost.com/entry/19th-century-women-medical-school_n_5093603.

ANN LOWE

Alleyne, Allyssia. "The Untold Story of Ann Lowe, the Black Designer behind Jackie Kennedy's Wedding Dress." CNN Style, CNN.com, December 23, 2020. edition.cnn.com/style/article/ann-lowe-jackie-kennedy-wedding-dress/index.html.

McVicker, Michelle. "1898–1981 – Ann Lowe." Fashion History Timeline, FIT. Updated August 4, 2020. fashionhistory.fitnyc.edu/1898-1981-ann-lowe.

Minutaglio, Rose. "Ann Lowe Is The Little Known Black Couturier Who Designed Jackie Kennedy's Iconic Wedding Dress." *Elle,* September 12, 2019. elle.com/fashion/a29019843/jackie-kennedy-wedding-dress-designer-ann-lowe.

ANNA SUI

Munzenrieder, Kyle. "My Life in Parties: Anna Sui's Punk-Adjacent Youth and Enduring Fashion Friendships." *W,* December 4, 2020.

wmagazine.com/culture/anna-sui-designer
-my-life-in-parties.

Presley, Lisa Marie. "Anna Sui." *Interview*,
December 19, 2010. interviewmagazine.com
/fashion/anna-sui#.

Tortolani, Patricia. "Anna Sui's New Exhibit
Reminds Us Of The Joy Of Dressing Up."
Ocean Drive, September 17, 2020. oceandrive
.com/anna-sui-fashion-exhibit.

Yotka, Steff. "Anna Sui Fall 2021 Ready-to-Wear
Collection: An Escapist Fantasy Rooted in
Real Style from Anna Sui." *Vogue*, February
16, 2021. vogue.com/fashion-shows/fall-2021
-ready-to-wear/anna-sui.

ANNIE DODGE WAUNEKA

Malladi, Lakshmeeramya. "Annie Dodge
Wauneka (1910–1997)." The Embryo
Project Encyclopedia, December 19, 2017.
embryo.asu.edu/pages/annie-dodge
-wauneka-1910-1997.

Niethammer, Carolyn. *I'll Go and Do More:
Annie Dodge Wauneka, Navajo Leader and
Activist*. Lincoln: University of Nebraska
Press, 2001.

Rangel, Valerie. "Biography of Annie Dodge
Wauneka." New Mexico History, July 21, 2015.
newmexicohistory.org/2015/07/21/biography
-of-annie-dodge-wauneka.

Saxon, Wolfgang. "Annie D. Wauneka, 87, Dies;
Navajo Medical Crusader." *New York Times*,
November 16, 1997. nytimes.com/1997/11/16
/us/annie-d-wauneka-87-dies-navajo-medical
-crusader.html.

ANNIE EASLEY

Easley, Annie J. "Annie J. Easley Oral History."
Interviewed by Sandra Johnson. NASA,
August 21, 2001. historycollection.jsc.nasa
.gov/JSCHistoryPortal/history/oral_histories
/NASA_HQ/Herstory/EasleyAJ/EasleyAJ_8
-21-01.htm.

Mills, Anne K. "Annie Easley, Computer Scien-
tist." NASA, September 21, 2015. nasa.gov
/feature/annie-easley-computer-scientist.

Samorodnitsky, Dan. "Meet Annie Easley, the
Barrier-Breaking Mathematician Who Helped
Us Explore the Solar System." Massive
Science, November 26, 2018. massivesci
.com/articles/annie-easley-facts-stem
-mathematician-nasa-scientist-discrimination.

BESSIE COLEMAN

Bradner, Liesl. "Meet the Daring Women of
Color Who Beat Bigotry in Aviation." KCET,
July 24, 2019. kcet.org/shows/blue-sky
-metropolis/meet-the-daring-women-of
-color-who-beat-bigotry-in-aviation.

Rich, Doris L. *Queen Bess: Daredevil Aviator*.
Washington: Smithsonian Institution Press,
1993.

Slotnik, Daniel E. "Overlooked No More: Bessie
Coleman, Pioneering African-American
Aviatrix." *New York Times*, December 11,
2019. nytimes.com/2019/12/11/obituaries
/bessie-coleman-overlooked.html.

BESSIE STRINGFIELD

Ferrar, Ann. "Bessie Stringfield, Southern
Distance Rider." National Motorcycle
Museum, 2002. nationalmcmuseum.org
/featured-articles/bessie-stringfield
-southern-distance-rider.

Stewart, Nikita. "Overlooked No More: Bessie B.
Stringfield, the 'Motorcycle Queen of Miami.' "
New York Times, April 5, 2018. nytimes
.com/2018/04/04/obituaries/overlooked
-bessie-stringfield.html.

Windsor, Natalie. "Bessie Stringfield — A True
Legend!" *Russ Brown* (blog), March 10, 2020.
russbrown.com/bessie-stringfield-a-true
-legend.

Zarrelli, Natalie. "Bessie Stringfield, the Bad-Ass
Black Motorcycle Queen of the 1930s." *Atlas
Obscura*, October 11, 2020. atlasobscura.com
/articles/bessie-stringfield-motorcycle-queen.

CARMEN RUPE

Darling, Laura. "Carmen Rupe." Making Queer History, October 20, 2019. makingqueerhistory.com/articles/2019/10/20/carmen-rupe.

Desmarais, Felix. "Portrait of Wellington Transgender Legend Carmen Rupe to Join National Gallery Collection." *Stuff*, September 15, 2019. stuff.co.nz/entertainment/arts/115780558/portrait-of-wellington-transgender-legend-carmen-rupe-to-join-national-gallery-collection.

Sly, Sonia. "Georgina Beyer on Carmen Rupe: "We Had to Live in This Twilight'" *Eyewitness*, RNZ, March 25, 2020. rnz.co.nz/national/programmes/eyewitness/audio/2018739709/georgina-beyer-on-carmen-rupe-we-had-to-live-in-this-twilight.

Townsend, Lynette. "Rupe, Carmen Tione." Dictionary of New Zealand Biography, first published in 2018. Te Ara —The Encyclopedia of New Zealand. Accessed September 28, 2020. teara.govt.nz/en/biographies/6r6/rupe-carmen-tione.

CELIA CRUZ

Arce, Rose. "Tens of Thousands Mourn 'Queen of Salsa.'" CNN.com, July 22, 2003. cnn.com/2003/SHOWBIZ/Music/07/22/cruz.funeral/.

"Biography: Celia Cruz." Celia Cruz — The Queen of Salsa, June 5, 2017. celiacruz.com/biography.

Fernández, Stefanie. "Celia Cruz's 'Son Con Guaguancó' and the Bridge to Fame In Exile." NPR, February 13, 2018. npr.org/2018/02/13/584004511/celia-cruzs-son-con-guaguanc-and-the-bridge-to-fame-in-exile.

Hansen, Lena. "LatinXcellence: Celia Cruz, the Queen of Salsa, Love, and Azúcar." *People En Español*, September 21, 2020. peopleenespanol.com/chica/celia-cruz-hispanic-heritage-month.

Machado, Melinda. "Celia Cruz: Queen of Salsa." National Museum of American History, October 2, 2019. *O Say Can You See?* americanhistory.si.edu/blog/2012/05/celia-cruz-queen-of-salsa.html.

CHARLOTTA BASS

Bennett, Jessica. "Overlooked No More: Before Kamala Harris, There Was Charlotta Bass." *New York Times*, September 4, 2020. nytimes.com/2020/09/04/obituaries/charlotta-bass-vice-president-overlooked.html.

Brandman, Mariana. "Charlotta Spears Bass." National Women's History Museum, 2020. womenshistory.org/education-resources/biographies/charlotta-spears-bass.

Karimi, Faith. "More than Half a Century before Kamala Harris Ran for Vice President, This Black Woman Did." CNN.com, August 14, 2020. cnn.com/2020/08/14/us/charlotta-bass-kamala-harris-trnd/index.html.

Portner, Jessica. "The Pioneering Charlotta Bass." National History Museum Los Angeles County. nhm.org/stories/pioneering-charlotta-bass.

CHIEN–SHIUNG WU

Chiang, Tsia-Chien. *Madame Wu Chien-Shiung: The First Lady of Physics Research*. Translated by Tang-Fong Wong. Singapore: World Scientific Publishing Company, 2013.

"Chien-Shiung Wu." Atomic Heritage Foundation. atomicheritage.org/profile/chien-shiung-wu.

"Chien-Shiung Wu Overlooked for Nobel Prize." AAUW. aauw.org/resources/faces-of-aauw/chien-shiung-wu-overlooked-for-nobel-prize.

"Dr. Chien-Shiung Wu, The First Lady of Physics." National Park Service, U.S. Department of the Interior. nps.gov/people/dr-chien-shiung-wu-the-first-lady-of-physics.htm.

Shoichet, Catherine E. "She Never Won a Nobel Prize. But Today This Pioneering Physicist Is Getting Her Face on a Stamp." CNN.com. Updated February 11, 2021. cnn.com/2021/02/11/us/chien-shiung-wu-stamp-scn/index.html.

DOLORES HUERTA

Godoy, Maria. "Dolores Huerta: The Civil Rights Icon Who Showed Farmworkers 'Sí Se Puede.' " *The Salt*, NPR, September 17, 2017. npr.org /sections/thesalt/2017/09/17/551490281 /dolores-huerta-the-civil-rights-icon-who -showed-farmworkers-si-se-puede.

Michals, Debra, ed. "Dolores Huerta." National Women's History Museum. 2015. womenshistory.org/education-resources /biographies/dolores-huerta.

Quinnell, Kenneth. "Women's History Month Profiles: Dolores Huerta." *AFL-CIO* Blog, March 21, 2019. aflcio.org/2019/3/21/womens -history-month-profiles-dolores-huerta.

DOROTHY TOY

Belanger, Jacques, dir. Oriental Playgirl Revue "Kawaii Baby." Scopitone Film. youtube.com /watch?v=9B486hIuKvM.

"Famed Dancer Dorothy Toy Reveals How Rival Sabotaged Career." CBS San Francisco, May 21, 2013. sanfrancisco.cbslocal. com/2013/05/21/famed-dancer-dorothy -toy-reveals-how-rival-sabotaged-career.

Genzlinger, Neil. "Dorothy Toy, 102, Half of Asian-American Dance Team, Dies." *New York Times*, August 1, 2019. nytimes.com/2019 /08/01/arts/dorothy-toy-dead.html.

Lam, Joseph. "Asian-American Dance Duo Dorothy Toy and Paul Wing, the 'Chinese Fred Astaire and Ginger Rogers,' and How They Captured Audiences' Hearts." *South China Morning Post*, September 3, 2020. scmp .com/lifestyle/entertainment/article /3099692/asian-american-dance-duo -dorothy-toy-and-paul-wing-chinese.

Quan, Rick, dir. *Dancing Through Life: The Dorothy Toy Story.* 2017. youtube.com /watch?v=YqPZEGjFvuU.

EARTHA KITT

Davies, Michelle. "How Eartha Kitt Defied the Odds to Become a Hollywood Screen Icon." *Marie Claire*, December 5, 2017. marieclaire.co.uk/entertainment/people /eartha-kitt-506205.

Dawson, Mackenzie. "IT'S MISS KITT, TO YOU." *New York Post*, October 9, 2007. nypost.com /2007/10/09/its-miss-kitt-to-you.

"Eartha Kitt." *Speaking Freely,* The Freedom Forum Institute. July 20, 2015. youtube.com /watch?v=8jEAjG6SegY.

Hersh, Seymour. "C.I.A. in '68 Gave Secret Service a Report Containing Gossip About Eartha Kitt After White House Incident." *New York Times*, January 3, 1975. nytimes.com /1975/01/03/archives/cia-in-68-gave-secret -service-a-report-containing-gossip-about .html.

Hoerburger, Rob. "Eartha Kitt, a Seducer of Audiences, Dies at 81." *New York Times*, December 25, 2008. nytimes.com/2008 /12/26/arts/26kitt.html.

Luck, Adam. "Eartha Kitt's Life Was Scarred by Failure to Learn the Identity of Her White Father, Says Daughter." *The Guardian*, October 19, 2013. theguardian.com/music /2013/oct/19/eartha-kitt-suffered-over -identity.

Meares, Hadley Hall. "C'est Si Bon: Eartha Kitt's Transformative Life." *Vanity Fair*, January 22, 2021. vanityfair.com/hollywood/2021/01 /eartha-kitt-old-hollywood-autobiography.

GEORGIA GILMORE

Blejwas, Emily. "Georgia Gilmore." Encyclopedia of Alabama. Last updated August 3, 2021. encyclopediaofalabama.org/article/h-4135.

Godoy, Maria. "Meet The Fearless Cook Who Secretly Fed— And Funded— The Civil Rights Movement." The Salt, NPR, January 15, 2018. npr.org/sections/thesalt/2018/01/15 /577675950/meet-the-fearless-cook-who -secretly-fed-and-funded-the-civil-rights -movement.

Miller, Klancy. "Overlooked No More: Georgia Gilmore, Who Fed and Funded the Montgomery Bus Boycott." *New York Times*, July 31, 2019, nytimes.com/2019/07/31/obituaries /georgia-gilmore-overlooked.html.

Robinson, Jo Ann Gibson. *The Montgomery Bus Boycott and the Women Who Started It*. Knoxville: University of Tennessee Press, 1987.

GLORIA ESTEFAN

Ellwood-Hughes. "Interview: Gloria Estefan Opens up about New Album Brazil305 and Looks Back at Her Iconic Album Mi Tierra." *Entertainment Focus*, August 23, 2020. entertainment-focus.com/2020/08/11 /interview-gloria-estefan-opens-up-about -new-album-brazil305-and-looks-back-at -her-iconic-album-mi-tierra.

"Gloria Estefan Reflects on Her Life Story in 'On Your Feet!' " *Here & Now*, WBUR, April 28, 2016. wbur.org/hereandnow/2016/04/28 /gloria-estefan-on-your-feet.

Ilich, Tijana. "Gloria Estefan: Biography of a Latin Superstar." *LiveAbout*, April 8, 2019. liveabout.com/gloria-estefan-biography -of-a-latin-superstar-2141119.

"Reflections on a Life Lived Fully with Gloria Estefan." Moderated by Shirin Tahir-Kheli, SAIS Events, May 11, 2018. youtube.com /watch?v=4vGilHL2bjY.

Walton, Kath. "On Your Feet—Interview with Gloria Estefan." At the Theatre, February 9, 2020. atthetheatre.co.uk/on-your-feet -interview-with-gloria-estefan.

GRACE LEE BOGGS

"Bill Moyers Talks with Grace Lee Boggs." Bill Moyers Journal, Transcripts. PBS, June 15, 2007. pbs.org/moyers/journal/06152007 /transcript3.html.

Boggs, Grace Lee. *Living for Change: An Autobiography*. Minneapolis: University of Minnesota Press, 2016.

Boggs, Grace Lee. "Partners in Struggle." *The Moth*. November 13, 2012. themoth.org /stories/partners-in-struggle.

Boggs, Grace Lee, and Scott Kurashige. *The Next American Revolution: Sustainable Activism for the Twenty-First Century*. Oakland: University of California Press, 2012.

Chow, Kat. "Grace Lee Boggs, Activist And American Revolutionary, Turns 100." *Code Switch*, NPR, June 27, 2015. npr.org/sections /codeswitch/2015/06/27/417175523/grace-lee -boggs-activist-and-american-revolutionary -turns-100.

Li, Sara. "Who Was Grace Lee Boggs, the Asian American Labor Organizer and Writer?" *Teen Vogue*, May 27, 2020. teenvogue.com/story /grace-lee-boggs-asian-american-labor -organizer-writer-og-history.

McFadden, Robert D. "Grace Lee Boggs, Human Rights Advocate for 7 Decades, Dies at 100." *New York Times*, October 5, 2015. nytimes .com/2015/10/06/us/grace-lee-boggs-detroit -activist-dies-at-100.html.

HAZEL YING LEE

Burmeister, Heather. "Hazel Ying Lee (1912–1944)." *The Oregon Encyclopedia*. Last updated January 22, 2021. oregonencyclopedia.org/articles/lee_hazel _ying.

Flaccus, Gillian. "Chinese American WASP Losing Her Anonymity." *Los Angeles Times*, May 11, 2003. latimes.com/archives/la-xpm -2003-may-11-adna-pilot11-story.html.

Gandhi, Lakshmi. "Remembering Hazel Lee, the First Chinese-American Female Military Pilot." NBCNews.com, March 16, 2018. nbcnews.com/news/asian-america /remembering-hazel-lee-first-chinese -american-female-military-pilot-n745851.

Hafner, Katie. "Overlooked No More: When Hazel Ying Lee and Maggie Gee Soared the Skies." *New York Times*, May 21, 2020. nytimes.com/2020/05/21/obituaries/hazel -ying-lee-and-maggie-gee-overlooked.html.

IDA B. WELLS

Bay, Mia. *To Tell the Truth Freely: The Life of Ida B. Wells*. New York: Hill and Wang, 2010.

Giddings, Paula J. To Tell the Truth Freely *Ida: A Sword Among Lions: Ida B. Wells and the Campaign Against Lynching*. New York: Harper, 2009.

Norwood, Arlisha. "Ida B. Wells-Barnett." National Women's History Museum. 2017. womenshistory.org/education-resources /biographies/ida-wells-barnett.

Smith, David. "Ida B Wells: The Unsung Heroine of the Civil Rights Movement." *The Guardian*, April 27, 2018. theguardian.com/world/2018 /apr/27/ida-b-wells-civil-rights-movement -reporter.

ISABEL ALLENDE

Allende, Isabel. "About Isabel." Isabel Allende. isabelallende.com/en/bio.

Beard, Alison. "Life's Work: An Interview with Isabel Allende." *Harvard Business Review*, September 7, 2017. hbr.org/2016/05/isabel -allende.

Pepitone, Julianne. " 'I Was a Feminist in Kinder-garten': Isabel Allende in Her New Memoir." NBCNews.com, March 23, 2021. nbcnews. com/know-your-value/feature/i-was -feminist-kindergarten-isabel-allende-her -new-memoir-ncna1261740.

Sturges, Fiona. "Isabel Allende: 'Everyone Called Me Crazy for Divorcing in My 70s. I've Never Been Scared of Being Alone.' " *The Guardian*, February 13, 2021. theguardian.com/books /2021/feb/13/isabel-allende-everyone-called -me-crazy-for-divorcing-in-my-70s-ive-never -been-scared-of-being-alone.

JOVITA IDÁR

Alexander, Kerri Lee. "Jovita Idár." National Women's History Museum. 2019. womenshistory.org/education-resources /biographies/jovita-idar.

González, Gabriela. *Redeeming La Raza: Transborder Modernity, Race, Respectability, and Rights*. New York: Oxford University Press, 2018.

Medina, Jennifer. "Overlooked No More: Jovita Idár, Who Promoted Rights of Mexican-Americans and Women." *New York Times*, August 7, 2020. nytimes.com/2020/08/07 /obituaries/jovita-idar-overlooked.html.

JOYCE CHEN

Alexander, Kerri Lee. "Joyce Chen." National Women's History Museum. 2018. womenshistory.org/education-resources /biographies/joyce-chen.

Chen, Stephen. "Chef. Restaurateur. Entrepre-neur." Joyce Chen Foods. joycechenfoods .com/legacy.

Polan, Dana. "Joyce Chen Cooks and the Upscaling of Chinese Food in America in the 1960s." Open Vault from GBH. openvault .wgbh.org/exhibits/art_of_asian_cooking /article.

Yue, Niu. "Carrying on a Chinese Food Legacy." *Chinadaily*, April 17, 2015. usa.chinadaily.com .cn/epaper/2015-04/17/content_20457464 .htm.

KALPANA CHAWLA

"Astronaut Friday: Kalpana Chawla." Space Center Houston. November 22, 2019. spacecenter.org/astronaut-friday-kalpana -chawla.

"Biographical Data: Kalpana Chawla." NASA. May 2004. nasa.gov/sites/default/files /atoms/files/chawla_kalpana.pdf.

Chengappa, Raj. "I Really Feel Responsible for the Earth Now: Kalpana Chawla." *India Today*. Updated March 6, 2013. indiatoday.in /magazine/interview/story/19980126-i-really -feel-responsible-for-the-earth-now-says -kalpana-chawla-825487-1998-01-26.

Mukherjee, Jashodhara. "17 Years After Kalpana Chawla's Death, Her Father Opens up about Her Dream." News18, October 11, 2020. news18.com/news/buzz/17-years-after -kalpana-chawlas-death-her-father-opens -up-about-her-dream-2941149.html.

KAMALA HARRIS

Harris, Scott Duke. "From the Archives: In Search of Elusive Justice." *Los Angeles Times*, October 24, 2004. latimes.com/politics /la-pol-ca-tm-kamala-20190121-story.html.

Kim, Catherine, and Zack Stanton. "55 Things You Need to Know About Kamala Harris." *POLITICO*, August 16, 2020. politico.com /news/magazine/2020/08/11/kamala-harris -vp-background-bio-biden-running-mate -2020-393885.

Lisby, Darnell-Jamal. "The True Meaning of Vice President Kamala Harris's Inauguration Outfit." *Teen Vogue*, January 21, 2021. teenvogue.com/story/the-meaning-of-vice -president-kamala-harris-inauguration-outfit.

Nadworny, Elissa. "Kamala Harris Sworn in as Vice President." NPR, January 20, 2021. npr. org/sections/inauguration-day-live-updates /2021/01/20/958749751/vice-president -kamala-harris-takes-the-oath-of-office.

"One of These Women Could Be Our Next President." *Marie Claire*, February 21, 2019. marieclaire.com/politics/a26412575/women -running-for-president-2020.

Witter, Brad. "10 Things You May Not Know about Kamala Harris." Biography.com. Updated January 20, 2021. biography.com /news/kamala-harris-facts.

KATHLEEN "KAY" LIVINGSTONE

Alward, Mary M. "Kay Livingstone." historyswomen.com/socialreformer /KayLivingstone.html.

Augustine, Jean. "Congress of Black Women of Canada." The Jean Augustine Political

Button Collection, York University Libraries. https://archives.library.yorku.ca/exhibits /show/pushingbuttons/black--caribbean -community/congress-of-black-women -of-can.

"Kay Livingstone." Congress of Black Women of Canada, Ontario Region. cbwc-ontario.com /kay-livingstone-1.

Livingstone, Rene. "Canada 150/150 : Kathleen Livingstone." *Canadian Race Relations Foundation.* Updated November 22, 2018. crrf-fcrr.ca/en/site-content/item/26937 -canada-150-150-kathleen-livingstone.

Yarhi, Eli. "Kay Livingstone." *The Canadian Encyclopedia*, March 5, 2019. thecanadianencyclopedia.ca/en/article /kay-livingstone.

MADONNA THUNDER HAWK

Castle, Elizabeth. "The Original Gangster." Towards Collective Liberation: Anti-Racist Organizing, Feminist Praxis, and Movement Building Strategy. Oakland, CA: PM Press, 2013.

Haiar, Joshua. In the Moment, episode 863, "Influential Women in SD: Madonna Thunder Hawk & Marcella Gilbert." Aired on July 21, 2020, on SDPB Radio. listen.sdpb.org /arts-culture/2020-07-21/influential-women -in-sd-madonna-thunder-hawk-marcella -gilbert.

"Native American Heritage Month: Madonna Thunder Hawk." Reproductive Health Access Project, November 30, 2018. reproductiveaccess.org/2018/11/native -american-heritage-month-madonna-thunder -hawk.

"Our Team." Warrior Women Project. warriorwomen.org/our-team.

Rao, Sameer. "New Documentary Chronicles Indigenous Activist History." *Colorlines*, May 16, 2018. colorlines.com/articles /new-documentary-chronicles-indigenous -activist-history.

MAE JEMISON

Alexander, Kerri Lee. "Mae Jemison." National Women's History Museum. 2019. womenshistory.org/education-resources /biographies/mae-jemison.

"Dr. Mae Jemison Interview." Scholastic.com, March 15, 2001. teacher.scholastic.com /space/mae_jemison/interview.htm.

Eschner, Kat. "This Groundbreaking Astronaut and Star Trek Fan Is Now Working on Interstellar Travel." *Smithsonian Magazine,* October 17, 2017. smithsonianmag.com /smart-news/groundbreaking-astronaut-and -star-trek-fan-now-working-interstellar -travel-180965277.

Greene, Nick. "Mae Jemison: An Astronaut Who Flew with NASA and Served with Starfleet." *ThoughtCo*, November 18, 2018. thoughtco .com/mae-c-jemison-3071170.

Katz, Jesse. "Shooting Star: Former Astronaut Mae Jemison Brings Her Message Down to Earth." *Stanford Today*, June 28, 2011. web .stanford.edu/dept/news/stanfordtoday /ed/9607/pdf/ST9607mjemison.pdf.

MARIA TALLCHIEF

Anderson, Jack. "Maria Tallchief, a Dazzling Ballerina and Muse for Balanchine, Dies at 88." *New York Times*, April 12, 2013. nytimes .com/2013/04/13/arts/dance/maria-tallchief -brilliant-ballerina-dies-at-88.html.

Halzack, Sarah. "Maria Tallchief, Ballet Star Who Was Inspiration for Balanchine, Dies at 88." *Washington Post*, April 12, 2013. washingtonpost.com/local/obituaries/maria -tallchief-ballet-star-who-was-inspiration-for -balanchine-dies-at-88/2013/04/12/5888f3de -c5dc-11df-94e1-c5afa35a9e59_story.html.

Norwood, Arlisha R. "Maria Tallchief." National Women's History Museum. 2017. womenshistory.org/education-resources /biographies/maria-tallchief.

Tallchief, Maria, and Larry Kaplan. *Maria Tallchief: America's Prima Ballerina*. New York: Henry Holt and Co., 1997.

MARIE VAN BRITTAN BROWN

Buck, Stephanie. "This African American Woman Invented Your Home Security System." *Medium*, Timeline, June 13, 2017. timeline.com/marie-van-brittan-brown -b63b72c415f0.

Hill, Rebecca. "Marie Van Brittan Brown (1922-1999)." *BlackPast.org,* October 23, 2019. blackpast.org/african-american-history /brown-marie-van-brittan-1922-1999.

Kelly, Kate. "Marie Van Brittan Brown: Home Security System Inventor." America Comes Alive, September 11, 2020. americacomesalive.com/marie-van-brittan -brown-home-security-system-inventor.

MARY GOLDA ROSS

Bark, Lindsey. "Mary Golda Ross: Mathematician, Engineer and Inspiration." *Cherokee Phoenix*. Updated May 23, 2021. cherokeephoenix.org/education/mary -golda-ross-mathematician-engineer-and -inspiration/article_35dde35c-7b67-11eb -a57a-df1679a79491.html.

Blakemore, Erin. "Google Doodle Honors Little-Known Math Genius Who Helped America Reach the Stars." *Smithsonian Magazine*. Updated August 9, 2018. smithsonianmag .com/smithsonian-institution/little-known -math-genius-helped-america-reach -stars-180962700.

Howard, Jenny. "Meet Mary Golda Ross, One of the First Native Americans in Engineering." *Massive Science*, May 17, 2018. massivesci .com/articles/mary-golda-ross-cherokee.

Sandberg, Ariel. "Remembering Mary Golda Ross." *Michigan Engineering*, June 14, 2017. news.engin.umich.edu/2017/06/remembering -mary-golda-ross. (site discontinued)

Sheppard, Laurel M. "An Interview with Mary Ross." Lash Publications International, nn.net /lash/maryross.htm.

Sorell, Traci. "Classified: The Secret Career of Mary Golda Ross, Cherokee Aerospace Engineer." Minneapolis, MN: Millbrook Press, 2021.

Viola, Herman. "Mary Golda Ross: She Reached for the Stars." *American Indian*. Winter 2018. americanindianmagazine.org/story/mary -golda-ross-she-reached-stars.

MISTY COPELAND

Bried, Erin. "Stretching Beauty: Ballerina Misty Copeland on Her Body Struggles." *SELF*, June 13, 2019. self.com/story/ballerina-misty -copeland-body-struggles.

Chu, Ying. "Misty Copeland: 'It's Important for Women to See Themselves Represented.'" *Glamour*, September 11, 2017. glamour.com /story/misty-copeland-glamour-october-2017.

"Misty Copeland on Changing the Face of Ballet | TIME 100 | TIME." *Time*, April 16, 2015. youtube.com/watch?v=ddarrb8u7p8.

"Misty Copeland on Power, Succession, and Breaking the Glass Ceiling." *Glamour*, November 10, 2015. glamour.com/video /watch/women-of-the-year-misty-copeland -on-power-succession-and-breaking-the -glass-ceiling.

"Misty Copeland on Remembering Her Roots." *Glamour*, August 22, 2017. glamour.com/video /watch/misty-copeland-on-remembering -her-roots.

Noll, Morgan. "Misty Copeland Says This Is the First Time She Feels Truly Heard as a Black Ballerina." *HelloGiggles*, February 12, 2021. hellogiggles.com/celebrity/misty-copeland -interview.

Woods, Astrida. "Misty's Magic." *Dance Magazine*, September 16, 2019. dancemagazine.com/mistys-magic -2306899149.html.

NANCY KWAN

Bai, Stephany. "Nancy Kwan Had Trouble Sustaining Her Hollywood Career. Now, She Thinks Opportunities Abound." NBCNews. com, April 22, 2019. nbcnews.com/news /asian-america/nancy-kwan-had-trouble -sustaining-her-hollywood-career-now -she-n873131.

Dragani, Mina. "How Vidal Sassoon Changed the World With a Hair Cut." *L'OFFICIEL USA*, January 17, 2021. lofficielusa.com/beauty /vidal-sassoon-hair-cuts-history.

Ford, Rebecca. "Ming-Na Wen, Nancy Kwan Talk Hollywood's New 'Awareness' on Diversity: 'It's Opening Up.' " *The Hollywood Reporter*, July 15, 2019. hollywoodreporter .com/news/ming-na-wen-nancy-kwan-talk -hollywoods-new-awareness-diversity -1206046.

King, Susan. "Code Breaker." *Los Angeles Times*, May 16, 2011. latimes.com/archives/la-xpm -2011-may-16-la-et-classic-hollywood -20110516-story.html.

Nahm, H.Y. "Suzie Wong Revisited." *Goldsea*. 1990. goldsea.com/Personalities/Kwannancy /kwannancy.html.

"Nancy Kwan: The Real 'Suzie Wong.'" Talk Asia, CNN.com, April 15, 2010. cnn.com/2010 /SHOWBIZ/04/15/talk.asia.nancy.kwan /index.html.

Soboleski, Hank. "Actress Nancy Kwan Filmed on Kauai." *The Garden Island*, February 18, 2019. thegardenisland.com/2018/10/21 /lifestyles/actress-nancy-kwan-filmed -on-kauai.

NAOMI OSAKA

Hart, Torrey. "Naomi Osaka Becomes First Individual Sport Athlete to Sit Out." *Front Office Sports*, August 27, 2020. frontofficesports .com/naomi-osaka-becomes-first-individual -sport-athlete-to-sit-out.

Larmer, Brook. "Naomi Osaka's Breakthrough Game." *New York Times*, August 23, 2018. nytimes.com/2018/08/23/magazine /naomi-osakas-breakthrough-game.html.

Lipsky-Karasz, Elisa. "Naomi Osaka on Fighting for No. 1 at the U.S. Open and Why She's Speaking Out." *Wall Street Journal*, August 25, 2020. wsj.com/articles/naomi-osaka -interview-us-open-kobe-blm-11598356462.

O'Malley, Katie. "Naomi Osaka: Everything To Know About The Tennis Champion And Fashion Trailblazer." *ELLE*, January 6, 2021. elle.com/uk/life-and-culture/culture /a35252315/naomi-osaka.

Osaka, Naomi. "I Never Would've Imagined Writing This Two Years Ago." *Esquire*, July 1, 2020. esquire.com/sports/a33022329/naomi -osaka-op-ed-george-floyd-protests.

Papisova, Vera. "Naomi Osaka on Mental Health and Training to Face Her Idol at the U.S. Open." *Teen Vogue*, September 11, 2018. teenvogue.com/story/naomi-osaka-us-open -champion-mental-health-serena-williams.

Plosser, Liz. "Naomi Osaka Is Playing The Long Game." *Women's Health*, August 23, 2021. womenshealthmag.com/fitness/a37169178 /naomi-osaka-mental-health-interview.

PATSY MINK

Alexander, Kerri Lee. "Patsy Mink." National Women's History Museum. 2019. womenshistory.org/education-resources /biographies/patsy-mink.

Gootman, Elissa. "Patsy Mink, Veteran Hawaii Congresswoman, Dies at 74." *New York Times*, September 30, 2002. nytimes.com /2002/09/30/us/patsy-mink-veteran-hawaii -congresswoman-dies-at-74.html.

"Patsy Mink." National Park Service, U.S. Department of the Interior. nps.gov/people /patsy-mink.htm.

Stringer, Kate. "No One Would Hire Her. So She Wrote Title IX and Changed History for Millions of Women. Meet Education Trail-blazer Patsy Mink." The 74, March 1, 2018. the74million.org/article/no-one-would-hire -her-so-she-wrote-title-ix-and-changed -history-for-millions-of-women-meet -education-trailblazer-patsy-mink.

PORTIA WHITE

"Black History Month: Celebrating Portia White." McMillan LLP. February 18, 2021. mcmillan.ca/news/black-history-month -celebrating-portia-white.

Godin, Barb. "Women of Interest—Portia White." *The Voice*, February 12, 2020. voicemagazine.org/2020/02/11/women-of -interest-portia-white.

Goodall, Lian. *Singing towards the Future: The Story of Portia White*. Toronto: Napoleon, 2008.

King, Betty Nygaard, et al. "Portia White." *The Canadian Encyclopedia*, February 9, 2021. thecanadianencyclopedia.ca/en/article /portia-white-emc.

"Portia White." VANSDA. vansda.ca/trailblazers /portia-white.

PURA BELPRÉ

Jiménez-García, Marilisa. "Pura Belpré Lights the Storyteller's Candle: Reframing the Legacy of a Legend and What it Means for the Fields of Latino/a Studies and Children's Literature." *Centro Journal* Volume 26, no. 1 (Spring 2014): pp. 110–147.

Sánchez González, Lisa. *The Stories I Read to the Children: The Life and Writing of Pura Belpré, the Legendary Storyteller, Children's Author, and New York Public Librarian*. New York: Centro Press, 2013.

Ulaby, Neda. "How NYC's First Puerto Rican Librarian Brought Spanish To The Shelves." NPR, September 8, 2016. npr.org/2016/09 /08/492957864/how-nycs-first-puerto-rican -librarian-brought-spanish-to-the-shelves.

RITA MORENO

Alexander, Kerri Lee. "Rita Moreno." National Women's History Museum, 2019. womenshistory.org/education-resources /biographies/rita-moreno.

"Career Achievement Award: Rita Moreno, Pre-sented by Mercedes-Benz." Peabody Awards. 2018. peabodyawards.com/award-profile /career-achievement-award-rita-moreno.

Kettler, Sara. "Rita Moreno Was Over Being Stereotyped in Hollywood, so She Quit Making Movies for Seven Years." Biography .com, October 15, 2020. biography.com /news/rita-moreno-stopped-making-movies.

Martin, Rachel. "Rita Moreno Reflects on Anita, Awards and Accents." NPR, March 7, 2013. npr.org/2013/03/10/173726066/rita-moreno -reflects-on-anita-awards-and-accents.

McElwaine, Sandra. "Rita Moreno, SAG Life Achievement Award Winner, Talks Brando, Elvis and *West Side Story*." *The Daily Beast*, January 15, 2014. thedailybeast.com/rita -moreno-sag-life-achievement-award-winner -talks-brando-elvis-and-west-side-story.

SANDRA OH

Desta, Yohana. "Sandra Oh's Been Waiting 30 Years for a Show Like *Killing Eve*." *Vanity Fair*, April 6, 2018. vanityfair.com /hollywood/2018/04/killing-eve-sandra-oh -interview.

Dockterman, Eliana. "Sandra Oh on Stereo-
types, 'Grey's Anatomy' and Her First Lead
Role in 'Killing Eve.'" *Time*, April 9, 2018.
time.com/5233452/sandra-oh-killing-eve
-new-show.

Felsenthal, Julia. "For Sandra Oh, *Killing Eve*
Was a Very Long Time Coming." *Vogue*, April
5, 2018. vogue.com/article/killing-eve-bbc
-sandra-oh-interview.

Fortini, Amanda. "Sandra Oh." *The Gentle-
woman*. Autumn & Winter 2018.
thegentlewoman.co.uk/library/sandra-oh.

Jung, Alex E. "The Protagonist." *Vulture*, August
21, 2018. vulture.com/2018/08/sandra-oh-on
-killing-eve-and-her-emmy-nomination.html.

Nelson Howe, Elena. "Sandra Oh Layers in Her
Ethnicity on 'Killing Eve' Because White Holly-
wood Does Not." *Los Angeles Times*, June 23,
2020. latimes.com/entertainment-arts/tv
/story/2020-06-23/sandra-oh-layers
-ethnicity-for-nuance-killing-eve.

Rubin, Rebecca. "Only 3.4% of Hollywood
Movies Feature API Actors in Leading Roles,
Study Shows." *Variety*, May 18, 2021. variety
.com/2021/film/news/hollywood-movies
-aapi-community-study-1234975584.

"Sandra Oh Moves from 'Sideways' to TV."
TODAY.com, March 22, 2005. today.com
/popculture/sandra-oh-moves-sideways
-tv-wbna7267758.

SHIRLEY CHISHOLM

Barron, James. "Shirley Chisholm, 'Unbossed'
Pioneer in Congress, Is Dead at 80." *New
York Times*, January 3, 2005. nytimes.com
/2005/01/03/obituaries/shirley-chisholm
-unbossedpioneer-in-congress-is-dead-at
-80.html.

Chisholm, Shirley. *Unbought and Unbossed*.
Washington: Take Root Media, 2010.

Landers, Jackson. "'Unbought And Unbossed':
When a Black Woman Ran for the White
House." *Smithsonian Magazine,* April 25,
2016. smithsonianmag.com/smithsonian
-institution/unbought-and-unbossed-when
-black-woman-ran-for-the-white-house
-180958699.

Michals, Debra. "Shirley Chisholm." National
Women's History Museum. 2015.
womenshistory.org/education-resources
/biographies/shirley-chisholm.

SONIA SOTOMAYOR

"Background on Judge Sonia Sotomayor."
Obama White House Archives, National
Archives and Records Administration, May
26, 2009. obamawhitehouse.archives.gov
/the-press-office/background-judge-sonia
-sotomayor.

Golden-Vasquez, Abigail. "Justice Sonia
Sotomayor Speaks out on Latino Identity and
Civic Engagement." Aspen Institute, July 7,
2020. aspeninstitute.org/blog-posts/justice
-sonia-sotomayor-speaks-latino-identity
-civic-engagement.

Hoffman, January. "A Breakthrough Judge:
What She Always Wanted." *New York Times*,
September 25, 1992. nytimes.com/1992/09
/25/news/a-breakthrough-judge-what-she
-always-wanted.html.

Mears, Bill. "Sotomayor Says She Was 'Perfect
Affirmative Action Baby.'" CNN.com, June 11,
2009. cnn.com/2009/POLITICS/06/11
/sotomayor.affirmative.action/index.
html?iref=24hours.

Powell, Michael, and Serge F. Kovaleski.
"Sotomayor Rose on Merit Alone, Her Allies
Say." *New York Times*, June 5, 2009. nytimes
.com/2009/06/05/us/politics/05judge.html.

"Sonia Sotomayor." Oyez. oyez.org/justices
/sonia_sotomayor.

Totenberg, Nina. "A Justice Deliberates:
Sotomayor on Love, Health and Family." NPR,
January 12, 2013. npr.org/2013/01/14
/167699633/a-justice-deliberates
-sotomayor-on-love-health-and-family.

Totenberg, Nina. "Sotomayor Opens up about
Diabetes for Youth Group." NPR, June 21,
2011. npr.org/2011/06/21/137328180
/sotomayor-opens-up-about-diabetes.

Wolf, Richard. "'The People's Justice': After
Decade on Supreme Court, Sonia Sotomayor
Is Most Outspoken on Bench and Off." *USA
Today*. Updated August 12, 2019.

usatoday.com/story/news/politics/2019
/08/08/justice-sonia-sotomayor
-supreme-court-liberal-hispanic
-decade-bench/1882245001.

STACEY ABRAMS

Ball, Molly. "Stacey Abrams Could Become
America's First Black Female Governor—If
She Can Turn Georgia Blue." *Time*, July 26,
2018. time.com/5349541/stacey-abrams
-georgia.

Darrisaw, Michelle, and Samantha Vincenty.
"14 Things to Know About Stacey Abrams."
Oprah Daily, November 6, 2020. oprahdaily
.com/life/a24749080/stacey-abrams-georgia
-governor-race-condede.

Herndon, Astead W. "Stacey Abrams Will Not
Run for President in 2020, Focusing Instead
on Fighting Voter Suppression." *New York
Times*, August 13, 2019. nytimes.com/2019/08
/13/us/politics/stacey-abrams-fair-fight-2020
.html.

Okeowo, Alexis. "Can Stacey Abrams Save
American Democracy?" *Vogue*, August 12,
2019. vogue.com/article/stacey-abrams
-american-democracy-vogue-september
-2019-issue.

Powell, Kevin. "The Power of Stacey Abrams."
Washington Post, May 14, 2020.
washingtonpost.com/magazine/2020/05
/14/stacey-abrams-political-power.

SUSAN LA FLESCHE PICOTTE

"Changing the Face of Medicine | Susan La
Flesche Picotte." U.S. National Library of
Medicine, National Institutes of Health.
Updated June 3, 2015. cfmedicine.nlm.nih
.gov/physicians/biography_253.html.

"Susan La Flesche Picotte: The First American
Indian Doctor." *American Masters,* PBS,
February 8, 2021. pbs.org/wnet
/americanmasters/meet-first-american
-indian-woman-physician-ienwy3/14818.

"Susan La Flesche Picotte." National Park
Service, U.S. Department of the Interior. nps
.gov/people/susan-la-flesche-picotte.htm.

Vaughan, Carson. "The Incredible Legacy of
Susan La Flesche, the First Native American
to Earn a Medical Degree." *Smithsonian
Magazine*, 1 March 1, 2017. smithsonianmag
.com/history/incredible-legacy-susan-la
-flesche-first-native-american-earn-medical
-degree-180962332.

SYLVIA RIVERA

Devaney, Susan. "Who Was Sylvia Rivera?
Marsha P. Johnson's Best Friend Was a Fellow
Pioneer." *British Vogue*, June 13, 2020. vogue
.co.uk/arts-and-lifestyle/article/who-was
-sylvia-rivera.

Reyes, Raul A. "A Forgotten Latina Trailblazer:
LGBT Activist Sylvia Rivera." *NBCNews.com*
. Updated October 6, 2015. nbcnews.com
/news/latino/forgotten-latina-trailblazer
-lgbt-activist-sylvia-rivera-n438586.

Rothberg, Emma. "Sylvia Rivera." National
Women's History Museum. 2021.
womenshistory.org/education-resources
/biographies/Sylvia-Rivera.

TRACEY NORMAN

Masters, Jeffrey. "Tracey 'Africa' Norman Looks
Back on Her Legendary Modeling Career."
The Advocate, February 2, 2021. advocate
.com/transgender/2021/1/27/transgender
-tracey-africa-norman-clairol-model.

Real, Evan. "Janet Mock, Tracey 'Africa' Norman
Talk Breaking Barriers, Being a 'Heroine for
Brown Trans Girls.'" *The Hollywood Reporter*,
May 2, 2019. hollywoodreporter.com/news
/janet-mock-tracey-africa-norman-talk
-breaking-barriers-1206050.

Sonoma, Serena. "Tracey Africa, Model *Pose*'s
Angel Is Based on, Rejected by *Playboy*." *Out,*
September 14, 2019. out.com/transgender
/2019/9/14/tracey-africa-model-poses
-angel-based-rejected-playboy.

Yuan, Jada, and Aaron Wong. "The First Black
Trans Model Had Her Face on a Box of
Clairol." *The Cut*, December 15, 2015. thecut
.com/2015/12/tracey-africa-transgender
-model-c-v-r.html.

VICTORIA DRAVES

Costa, Dr. Margaret. "An Olympian's Oral History: Vicki Draves." LA84 Foundation. December 1999. digital.la84.org/digital/collection/p17103coll11/id/51.

Francisco, Eric. "Why Vicki Draves' Story Is So Powerful, 72 Years Later." *Inverse*, August 3, 2020. inverse.com/culture/vicki-draves.

Litsky, Frank. "Victoria Manalo Draves, Olympic Champion Diver, Dies at 85." *New York Times*, April 30, 2010. nytimes.com/2010/04/30/sports/olympics/30draves.html.

"Vicki Draves, the first woman to achieve diving's golden double." International Olympic Committee. olympic.org/news/vicki-draves-diving.

WHINA COOPER

"Celebrating Dame Whina Cooper and the Fight for Māori Land Rights." New Zealand Parliament. Last updated December 9, 2020. parliament.nz/en/get-involved/features/celebrating-dame-whina-cooper-and-the-fight-for-maori-land-rights.

"A Hīkoi That Changed Aotearoa New Zealand Forever." New Zealand Parliament. October 9, 2015. parliament.nz/mi/get-involved/features-pre-2016/document/00NZPHomeNews201510101/a-h%C4%ABkoi-that-changed-aotearoa-new-zealand-forever.

Michael King. "Cooper, Whina," Dictionary of New Zealand Biography, first published in 2000. Te Ara —The Encyclopedia of New Zealand. teara.govt.nz/en/biographies/5c32/cooper-whina.

WILMA MANKILLER

Brando, Elizabeth. "Wilma Mankiller." National Women's History Museum. 2021. womenshistory.org/education-resources/biographies/wilma-mankiller.

Carrillo, Sequoia. "Just Doing 'What I Could,' Wilma Mankiller Changed Native America." *Smithsonian Magazine,* August 11, 2017. smithsonianmag.com/blogs/national-museum-american-indian/2017/08/11/just-doing-what-i-could-wilma-mankiller-changed-native-america.

MICA Group. "The Life of Wilma Mankiller, First Woman to Serve as Principal Chief of the Cherokee Nation: National Trust for Historic Preservation." National Trust for Historic Preservation. savingplaces.org/guides/wilma-mankiller-first-woman-principal-chief-cherokee-nation.

Verhovek, Sam Howe. "Wilma Mankiller, Cherokee Chief and First Woman to Lead Major Tribe, Is Dead at 64." *New York Times*, April 7, 2010. nytimes.com/2010/04/07/us/07mankiller.html.

YAYOI KUSAMA

Adams, Tim. "Yayoi Kusama: the World's Favourite Artist?" *The Guardian*, September 23, 2018. theguardian.com/artanddesign/2018/sep/23/yayoi-kusama-infinity-film-victoria-miro-exhibition.

Fifield, Anna. "How Yayoi Kusama, the 'Infinity Mirrors' Visionary, Channels Mental Illness into Art." *Washington Post*, February 15, 2017. washingtonpost.com/entertainment/museums/how-yayoi-kusama-the-infinity-mirrors-visionary-channels-mental-illness-into-art/2017/02/15/94b5b23e-ea24-11e6-b82f-687d6e6a3e7c_story.html.

Gomez, Edward M. "A 60's Free Spirit Whose Main Subject Was Herself." *New York Times*, July 5, 1998. nytimes.com/1998/07/05/arts/art-a-60-s-free-spirit-whose-main-subject-was-herself.html.

Pound, Cath. "Yayoi Kusama's Extraordinary Survival Story." Culture, BBC, September 26, 2018. bbc.com/culture/article/20180925-yayoi-kusamas-extraordinary-survival-story.

Swanson, Carl. "The Art of the Flame-Out."
New York, July 6, 2012. nymag.com/arts/art
/features/yayoi-kusama-2012-7/.

Tatehata, Akira. "INTERVIEW: Yayoi Kusama on
Sixties New York, Surviving Mental Illness and
Why She's Never Thought About Feminism."
Artspace, May 5, 2020. artspace.com
/magazine/interviews_features/meet_the
_artist/interview-yayoi-kusama-on-sixties
-new-york-living-with-mental-illness-and
-why-shes-never-thought-56560.

"Yayoi Kusama: Look Now, See Forever." Yayoi
Kusama Timeline. 2011. Queensland Art
Gallery and Gallery of Modern Art. play
.qagoma.qld.gov.au/looknowseeforever
/timeline.

ZITKÁLA-ŠÁ

Capaldi, Gina. *Red Bird Sings: The Story of
Zitkala-Sa, Native American Author, Musician,
and Political Activist.* Minneapolis, MN:
Millbrook Press, 2011.

Editors of *Encyclopaedia Britannica.* "Zitka-
la-Sa." *Encyclopedia Britannica,* February 18,
2021. britannica.com/biography/Zitkala-Sa.

"Life Story: Zitkala-Sa, aka Gertrude
Simmons Bonnin (1876-1938)." Women
& the American Story, New York Historical
Society Museum and Library. wams.nyhistory
.org/modernizing-america/xenophobia
-and-racism/zitkala-sa.

Rappaport, Doreen. *The Flight of Red Bird: The
Life of Zitkala-Sa.* New York: Dial Books, 1997.

Rappaport, Helen. "Bonnin, Gertrude." In
Encyclopedia of Women Social Reformers,
vol. 1, 100–101. Santa Barbara, CA: ABC-CLIO,
2001.

"Zitkala-Ša (Red Bird / Gertrude Simmons
Bonnin)." National Parks Service, U.S.
Department of the Interior. nps.gov/people
/zitkala-sa.htm.

Acknowledgments

Many thanks to my wonderful editor, Deanne Katz, at Chronicle Books for helping me shepherd this book into existence. Special thanks to the stellar team of copyeditors, sensitivity readers, and proofreaders for ensuring this is the best, most inclusive version of this book possible. I'm also grateful to my fantastic team at Chronicle Books for creating extraordinary work in these extraordinary times. I'm so honored to be among your authors.

I'm eternally grateful for my wonderful agent, Monika Verma, for her support, guidance, and friendship since day one—here's to many more books to come. Thank you to the entire team at Levine Greenberg Rostan Literary Agency, for always having my back.

Thank you to my friends and family for listening to me as I wrung my hands over this manuscript, entertaining the endless facts I shared in research, brainstorming ideas with me, and overall being the greatest people I know. It took me a long time to get to a place where I feel like I have good friends, and I am so happy to be here. No one succeeds alone, and I'm happy to be on this journey in life with all of you.

Thank you to my own little family—my husband and love of my life, Ryan Shaw, for being just the very best human I could ever be lucky enough to be loved by, and all my animals for reminding me that there are so many things to marvel at in the world beyond work.

And finally, last but not least, thank you so much, dear reader. All of this is because of and for you, and as long as you keep showing up—so will I.

ABOUT THE AUTHOR

Ann Shen is the bestselling illustrator and author behind many beautiful projects, including *Bad Girls Throughout History*, *Legendary Ladies*, and *Nevertheless, She Wore It*. She specializes in bright, magical artwork that helps people feel less alone. Her clients include Disney, Adobe, Facebook, Jeni's Splendid Ice Creams, and more. In her free time, she enjoys treasure hunting at flea markets, raising puppies, kittens, and chickens with her husband, and growing a flower garden in Los Angeles. Find her online at www.ann-shen.com and on Instagram @anndanger.